Cool Restaurants Brussels

teNeues

Imprint

Editor:	Eva Raventós
Photography:	David Cardelús
Copyediting:	Alicia Capel, Susana González
Layout & Pre-press:	Emma Termes Parera
Translations:	Michael Brunelle (English), Susanne Engler (German) Marion Westerhoff (French), Erika Venis (Dutch)

Produced by Loft Publications
www.loftpublications.com

Published by teNeues Publishing Group

teNeues Publishing Company
16 West 22nd Street, New York, NY 10010, USA
Tel.: 001-212-627-9090, Fax: 001-212-627-9511

teNeues Book Division
Kaistraße 18, 40221 Düsseldorf, Germany
Tel.: 0049-(0)211-994597-0, Fax: 0049-(0)211-994597-40

teNeues Publishing UK Ltd.
P.O. Box 402, West Byfleet, KT14 7ZF, Great Britain
Tel.: 0044-1932-403509, Fax: 0044-1932-403514

teNeues France S.A.R.L.
4, rue de Valence, 75005 Paris, France
Tel.: 0033-1-55 76 62 05, Fax: 0033-1-55 76 64 19

teNeues Iberica S.L.
Pso. Juan de la Encina 2-48, Urb. Club de Campo
28700 S.S.R.R., Madrid, Spain
Tel./Fax: 0034-91-65 95 876

www.teneues.com

ISBN-10:	3-8327-9065-9
ISBN-13:	978-3-8327-9065-3

© 2005 teNeues Verlag GmbH + Co. KG, Kempen

Printed in Italy

Bibliographic information published by Die Deutsche
Bibliothek. Die Deutsche Bibliothek lists this
publication in the Deutsche Nationalbibliografie;
detailed bibliographic data is available in the Internet
at http://dnb.ddb.de.

Contents
Page

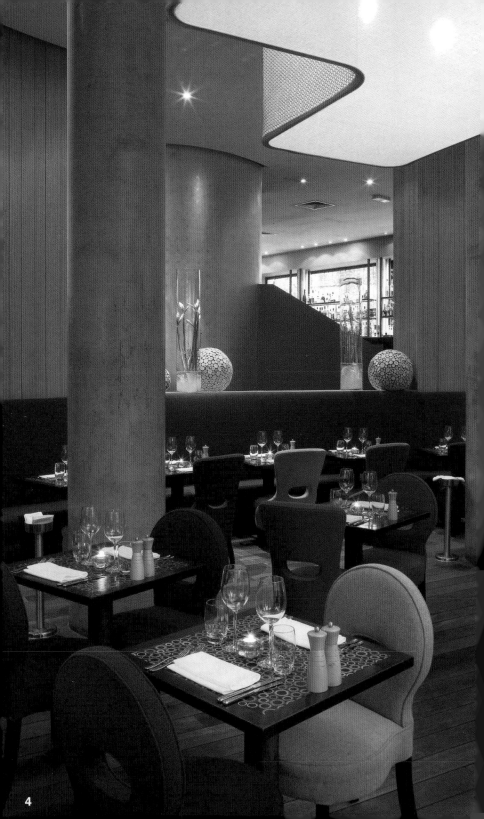

Introduction

Siège de l'Union européenne et d'importants organismes internationaux, Bruxelles est vraiment à la croisée des chemins de plusieurs pays d'Europe. Autour de la Grande Place –place historique du marché et nœud commercial dès le Moyen Age– s'organise le centre médiéval d'une ville qui, outre le fait d'être une enclave politique et diplomatique, cache beaucoup d'aspects et d'endroits retirés peu connus. L'Atomium, le Manneken Pis, Victor Horta ou la meilleure bière d'Europa ne sont que quelques-unes des images de marque de la capitale belge, significatives en tant que telles mais insuffisantes pour définir son essence même. Il y a une différence de style fondamentale entre la dénommée Ville Basse (le centre historique, fondé officiellement à la fin du Xe siècle à partir d'un îlot de fortifications), qui conserve l'esprit corporatif enchanteur, et la Ville Haute, accueillant des constructions de styles architecturaux divers. En effet, les cathédrales et églises gothiques – style propre au centre historique – se mêlent aux façades néoclassiques, édifices Art Nouveau et aux intérieurs Art Déco, dans un ensemble de perfection et d'harmonie, embelli par les nombreux parcs et musées qui confirment la passion des belges pour l'art. Outre la population habituelle, face au grand nombre de congrès internationaux qui se déroulent à Bruxelles, l'hôtellerie et la restauration doivent élargir leur gamme d'offre pour accueillir les milliers de visiteurs que la ville reçoit toute l'année. Dans ce domaine, il y a pléthore d'établissements pour tous les goûts et pour toutes les bourses. Cuisine traditionnelle belge et française, nouveau concept de « slow food », restaurants d'influence orientale ou arabe, établissements polyvalents à vocation artistique ou restaurant classique d'inspiration moderniste, à l'instar de Comme Chez Soi, autant d'exemples réunis dans la sélection proposée par ce guide de restaurants, choisis pour le concept que propose chaque espace, pour la renommée de leur gastronomie et, parfois, pour un design qui sort de l'ordinaire et se démarque de la traditionnelle sobriété bruxelloise. En définitive, ce sont des endroits qui confèrent des touches de couleurs et de créativité à une ville élégante et conciliatrice, toujours en activité, au flair classique avant tout et enfin, symbole de la splendeur européenne.

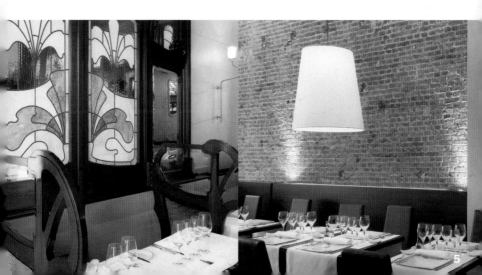

Inleiding

Brussel is de zetel van de Europese Gemeenschap en andere belangrijke organisaties. De Belgische stad ligt op het kruispunt van een aantal belangrijke Europese hoofdwegen. La Grand Place, een oude markt en sinds de Middeleeuwen het commerciële centrum van Brussel, vormt het historische hart van een stad die veel meer is dan een politieke en diplomatieke enclave, en vol zit met onbekende hoekjes en bezienswaardigheden. Het Atomium, Manneke Pis, Victor Horta en het beste bier van Europa zijn te vinden in de Belgische hoofdstad. En dat is nog maar het begin, want hiermee is de essentie van Brussel nog bij lange na niet gedefinieerd. Er is een fundamenteel verschil in stijl tussen de zogenaamde onderstad, het historische centrum dat volgens de boeken aan het eind van de 10e eeuw werd gesticht rond een versterking op een eiland en dat gekenmerkt wordt door de charmante, oude gildenhuizen, en de bovenstad. Hier vindt u huizen uit allerlei verschillende bouwkundige stijlen: gotische kerken en kathedralen (een stijl die men eerder in het oude centrum zou verwachten) staan naast neoclassicistische façades, art-nouveaugebouwen en art-decointerieurs. De goed onderhouden en visueel homogene bebouwing wordt afgewisseld door meerdere parken en musea, die de Belgische passie voor kunst benadrukken. Door de internationale congresse, die in Brussel worden gehouden, is een ruime keuze aan hotels en restaurants nodig om de duizenden bezoekers te herbergen die de stad bezoeken. Deze restaurants zijn er in alle smaken en prijsklassen. Er zijn traditionele Belgische en Franse keuken, nieuwe slow-foodkeuken, restaurants met Aziatische en Arabische invloeden, multifunctionele gelegenheden met artistieke flair, modernistische restaurants of juist klassiek, zoals Comme Chez Soi. Alle zijn opgenomen in deze restaurantgids, die bijzonder is omdat bij de keuze voor de restaurants rekening is gehouden met het concept, de vermaarde kookkunst, en soms ook met een ontwerp dat net iets opvallender is dan de gebruikelijke Belgische soberheid. Tot slot zijn dit restaurants die kleur en creativiteit verlenen aan een elegante en verzoeningsgezinde stad, die nooit rust, ondanks de ogenschijnlijk conservatieve uitstraling. Brussel is een echt symbool voor Europese pracht en praal.

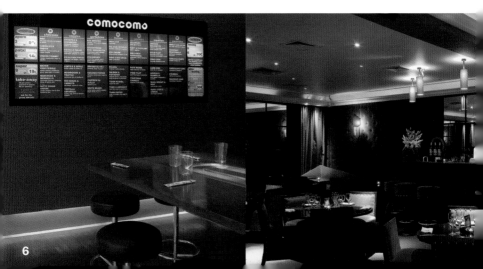

Introduction

Brussels, the seat of the European Community and other important international organizations, is located at the crossroads of several European countries. La Grand Place, a historic market place and commercial center since the Middle Ages, is the medieval center of a city that, in addition to being a political and diplomatic enclave, hides many other little known corners and attractions. The Atomium, the Mannekin Pis, Victor Horta, and the best beer in Europe are just some of the things to enjoy in the Belgian capital, a meaningful introduction but not enough when it comes to defining its essence. There is a fundamental difference in style between the so-called Lower City, which is the historic center, officially founded at the end of the 10th century in a fortification on an island, still steeped in the charming atmosphere of the city's guildhalls, and the Upper City. This has buildings of several different architectural styles; the gothic churches and cathedrals (a style more typical of the historic center) blend with the neoclassic façades, the Art Nouveau buildings, and the Art Deco interiors. The well-kept and visually coherent setting is embellished with numerous parks and museums that corroborate the Belgian passion for art. In addition to its normal population, the many international congresses that are celebrated in Brussels make necessary a wide offering of hotels and restaurants to serve the thousands of visitors to the city throughout the year. Among them are places for all tastes and economic levels. Traditional Belgian and French cuisines, the new concept of "slow food", restaurants with Asian and Arab influences, multifunctional places with an artistic flair, or a classic of Modernist inspiration like Comme Chez Soi are the places included in this restaurant guide, which is unique for taking into account the concept of each place, for its renowned gastronomy, and on occasion, for a design that is a little more striking than is usual for the accustomed Belgian sobriety. Finally, these are restaurants that add color and creativity to an elegant and conciliatory city, which is always active despite its supposedly classical mood. Brussels is a true symbol of European splendor.

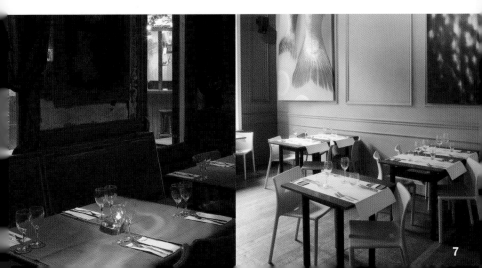

Einleitung

Brüssel, Sitz der Europäischen Union und wichtiger internationaler Organisationen, nimmt sozusagen den Platz an einer Wegkreuzung verschiedener europäischer Länder ein. Um den Grand Place, historischer Marktplatz und Zentrum der Handelsaktivitäten seit dem Mittelalter, liegt die mittelalterliche Stadtmitte, die nicht nur eine politische und diplomatische Enklave ist, sondern auch viele andere, weniger bekannte Aspekte verbirgt. Das Atomium, Manneken Pis, Victor Horta und das beste Bier Europas sind nur einige der Wahrzeichen der belgischen Hauptstadt, die uns die Stadt näher bringen, aber noch lange nicht ihre Besonderheit hervorheben. Der stilistische Unterschied zwischen der sogenannten Unter- und Oberstadt ist fundamental. Die Unterstadt ist das historische Zentrum, das offiziell gegen Ende des 10. Jh. mit der Befestigung einer Insel gegründet wurde und den Zauber der Zünfte bewahrt hat. In der Oberstadt findet man verschiedene architektonische Stile. Die gotischen Kathedralen und Kirchen, die eigentlich eher zur Unterstadt gehören sollten, verschmelzen mit neoklassizistischen Fassaden, Gebäuden des Art Nouveau und Innenräumen im Stil des Art Déco, das alles in einer gepflegten und harmonischen Umgebung, die von zahlreichen Parks und Museen verschönert wird, die die Vorliebe der Belgier für die Kunst belegen. Die Stadt Brüssel benötigt ihr weites gastronomisches Angebot, nicht nur, um die Bürger selbst, sondern auch um Tausende von Besuchern zufriedenzustellen, die Brüssel anlässlich vieler internationaler Kongresse, die hier stattfinden, das ganze Jahr hindurch besuchen. Auch hier ist die Vielfalt oberstes Gebot und man findet Restaurants für jeden Geschmack und Geldbeutel. Die traditionelle belgische und französische Küche, das neue Konzept „slow food", orientalisch und arabisch beeinflusste Restaurants, multifunktionale Lokale, die sich der Kunst verschrieben haben, oder einen Klassiker des Modernismus wie Comme Chez Soi finden Sie in diesem Restaurantführer, der das zugrundeliegende Konzept eines jeden Restaurants vorstellen möchte, aber auch die jeweilige Gastronomie sowie das Design, das sich manchmal von der traditionellen belgischen Nüchternheit abhebt. Kurz gesagt, wir stellen Ihnen Lokale vor, die Brüssel mit ihrer Vielfalt und Kreativität bereichern – eine elegante, friedliche und immer aktive Stadt, die im Ruf steht, sehr klassisch zu sein und die ein Symbol für europäische Pracht ist.

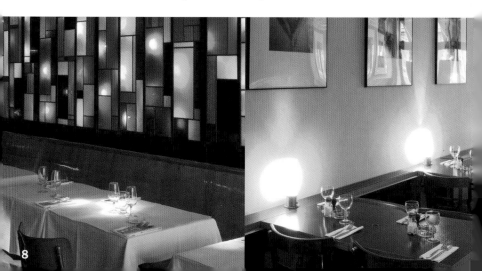

Introducción

Sede de la Unión Europea y de importantes organismos internacionales, Bruselas está emplazada en un verdadero cruce de caminos de varios países europeos. Alrededor de la Grand Place –histórica plaza del mercado y núcleo comercial desde la Edad Media– se articula el centro medieval de una ciudad que, además de ser un enclave político y diplomático, esconde muchos otros aspectos y rincones escasamente conocidos. El Atomium, el Manneken Pis, Victor Horta o la mejor cerveza de Europa son sólo algunos de los emblemas de la capital belga, significativos como aproximación pero insuficientes a la hora de definir su esencia. Resulta fundamental la diferencia de estilos entre la llamada Ciudad Baja (el centro histórico, oficialmente fundado a finales del siglo X a partir de una fortificación en una isla), que conserva el encanto gremial, y la Ciudad Alta, que alberga construcciones de diversos estilos arquitectónicos; así, las catedrales e iglesias góticas –estilo más propio del casco antiguo– se funden con fachadas neoclásicas, edificios Art Nouveau e interiores Art Déco en un conjunto cuidado y nada estridente, embellecido con numerosos parques y museos que corroboran la pasión belga por el arte. Además de su población habitual, el gran número de congresos internacionales que se celebran en Bruselas hace necesaria una amplia oferta de hostelería y restauración para atender a los miles de visitantes que recibe la ciudad durante todo el año. En este campo impera también la variedad y los locales para todos los gustos y niveles adquisitivos. La "cuisine" tradicional belga y francesa, el nuevo concepto de "slow food", restaurantes de influencia oriental o árabe, locales multifuncionales con vocación artística o un clásico de inspiración modernista como Comme Chez Soi conforman la selección incluida en esta guía de restaurantes, que destaca por el concepto de local que propone cada espacio, por su renombrada gastronomía y, en alguna ocasión, por un diseño un poco más llamativo que se desmarca de la acostumbrada sobriedad bruselense. En definitiva, lugares que aportan matices de color y creatividad a una ciudad elegante y conciliadora, siempre activa, de talante pretendidamente clásico y símbolo del esplendor europeo.

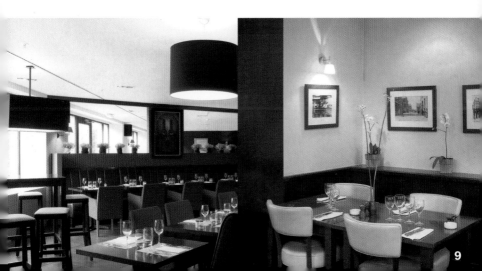

Agastache & Tonka

Design: Nicola Perini I Chef: Claude Pohlig

Rue Royale 290 I 1210 Brussels
Phone: +32 2 217 58 02
www.agastache-tonka.be
Subway: Botanique
Opening hours: Mon–Fri from 11:30 am to 2 pm, and Fri–Sat from 6:30 pm to 9 pm,
closed on Saturday at lunch time and on Sunday
Average price: € 40
Cuisine: Natural and creative French cuisine
Special features: Garden

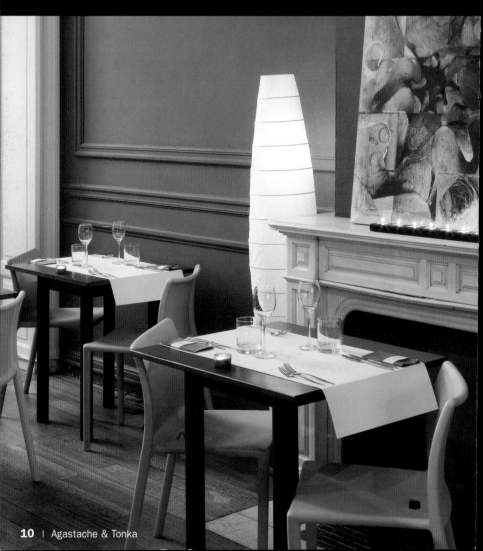

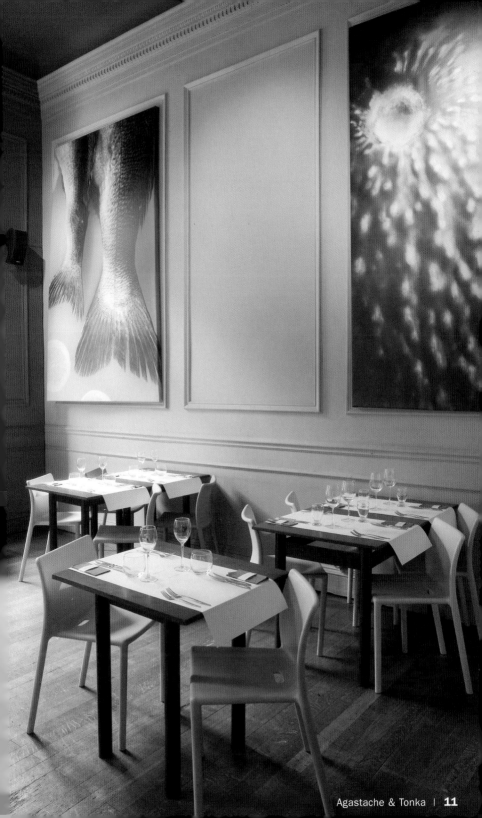

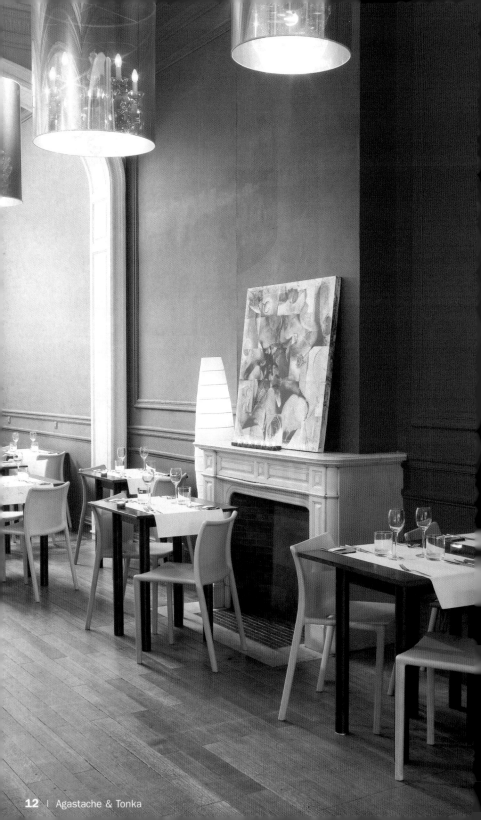

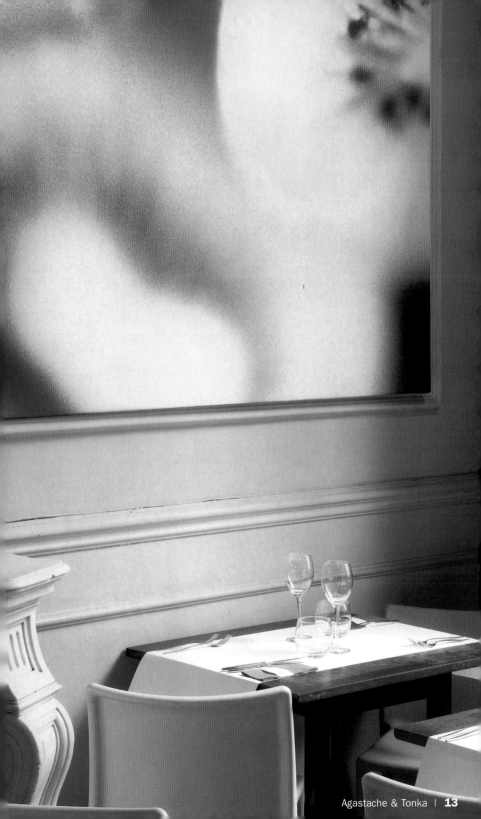

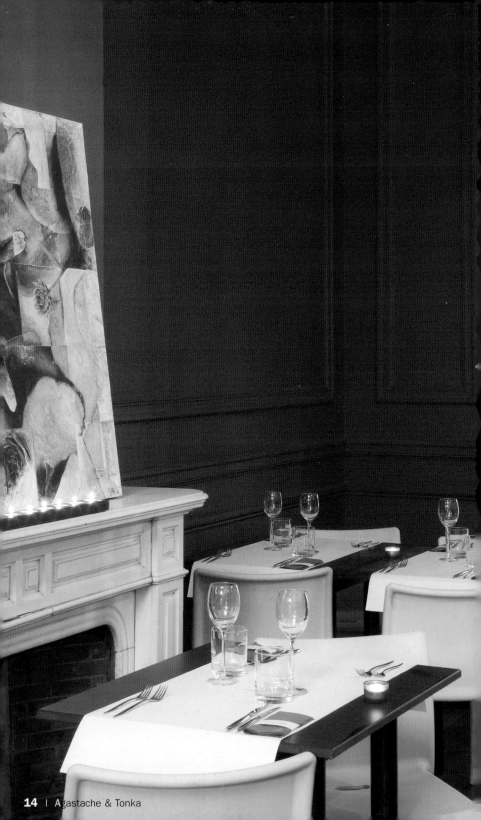

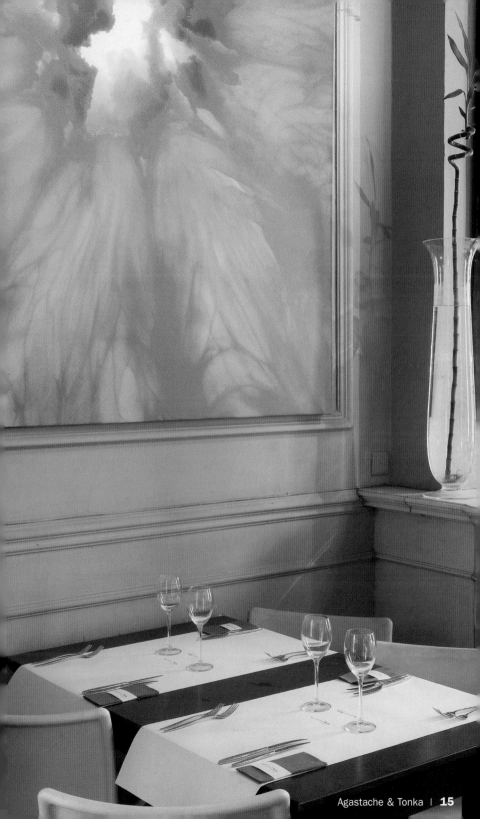

Bazaar

Design: Nadia Bakkali, Vincent van Oost | Chef: Bun Ponathirak

Rue des Capucins 63 | 1000 Brussels
Phone: +32 2 511 26 00
www.bazaarresto.be
Subway: Porte de Hal
Opening hours: Tue–Sat from 7:30 pm to 11 pm (restaurant), Fri–Sat from 10 pm to 4 am (nightclub)
Average price: € 20–30
Cuisine: Moroccan and fusion cuisine
Special features: Based on the cellar of a Capucins monastery

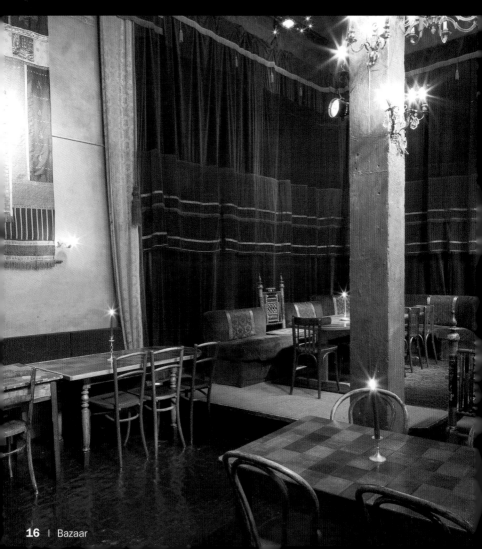

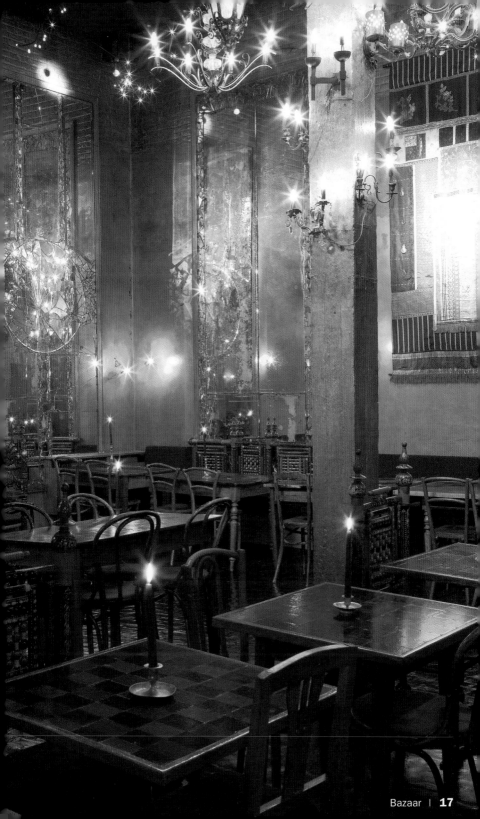

Roussette sautée
avec des tomates cherry

Gebakken hondshaai met kerstomaten
Dogfish Sautéed with Cherry Tomatoes
Sautierter Eber-Lippfisch mit Cherrytomaten
Pez perro salteado con tomates cherry

1 filet de roussette
2 oignons émincés
8 tomates cherry coupées en deux
1 échalote coupée très finement
1 gousse d'ail émincé
45 ml d'huile d'olive vierge extra
5 g beurre
30 g de purée de pommes
100 g haricots verts
Paprika
Sel
Poivre

Préchauffer une poêle avec la moitié de l'huile d'olive et la beurre. Rincer et essuyer le filet de roussette, le frire à feu vif. Assaisonner. Réduire à feu moyen et faire cuire pendant 10 minutes, sans le retourner. Préchauffer une autre poêle et déposer le reste de l'huile d'olive. Faire sauter l'ail, les tomates cherry, les oignons, l'échalote et le piment.
Presentation : Sur une assiette creuse, disposer un fond de purée de pommes de terre et de haricots verts et mettre le poisson au centre. Ajouter les tomates, les oignons et l'ail sautés.

1 hondshaaifilet
2 uien, gehakt
8 gehalveerde kerstomaatjes
1 sjalotje, fijngehakt
1 uitgeperst teentje knoflook, gehakt
45 ml extra virgine olijfolie
5 g boter
30 g aardappelpuree
100 g tuinbonen
Paprikapoeder
Zout
Peper

Verhit olijfolie en boter in een koekenpan. Dep de vis droog en bak deze op hoog vuur. Bestrooi met zout en peper, draai het vuur lager en bak de vis nog 10 minuten zonder te keren. Verhit de rest van de olijfolie in een andere koekenpan en fruit hierin knoflook, kerstomaten, sjalotje en paprikapoeder.
Serveren: Schep op een diep bord een bedje van aardappelpuree en tuinbonen, en leg de vis erop. Voeg kerstomaten, uien en knoflook toe en garneer.

1 dogfish filet
2 onions chopped
8 cherry tomatoes cut in half
1 shallot chopped very fine
1 garlic clove minced
45 ml extra virgin olive oil
1/5 oz of butter
2 oz pureed potatoes
3 1/2 oz green fava beans
Paprika
Salt
Pepper

Preheat a frying pan with half olive oil and the butter. Dry the dogfish filet and fry it on a high heat. Add salt and pepper. Reduce the heat to medium and cook for 10 minutes without turning it. Preheat another frying pan and put in the rest of the olive oil. Sauté the garlic, cherry tomatoes, onions, shallot, and the paprika. To serve: In a deep dish prepare a base of pureed potatoes and green fava beans and place the fish in the center. Add the sautéed tomatoes, onions, and garlic.

1 Filet vom Eber-Lippfisch
2 gehackte Zwiebeln
8 Cherrytomaten, halbiert
1 fein gehackte Schalotte
1 gehackte Knoblauchzehe
45 ml Olivenöl
5 g Butter
30 g Kartoffelpüree
100 g Grüne Bohnen
Paprikapulver
Salz
Pfeffer

Die Hälfte des Olivenöls und die Butter in einer Pfanne erhitzen. Das Fischfilet trocknen und auf hoher Flamme braten. Pfeffern und salzen. Die Kochtemperatur senken und 10 Minuten lang auf niedriger Flamme kochen, ohne den Fisch zu wenden. Eine andere Pfanne vorwärmen und das übrige Olivenöl hineingeben. Den Knoblauch, die Cherrytomaten, die Zwiebeln und die Schalotte darin sautieren und das Paprikapulver hinzugeben.
Serviervorschlag: Auf einem Suppenteller eine Unterlage aus Kartoffelpüree und grünen Bohnen formen und den Fisch in die Mitte geben. Die gebratenen Tomaten, Zwiebeln und den Knoblauch daneben anrichten.

1 filete de pez perro
2 cebollas picadas
8 tomates cherry cortados por la mitad
1 chalote cortado muy fino
1 diente de ajo picado
45 ml de aceite de oliva virgen extra
5 g de mantequilla
30 g de puré de patata
100 g judías verdes
Pimentón
Sal
Pimienta

Precalentar una sartén la mitad aceite de oliva y la mantequilla. Secar el filete de pez perro y freírlo a fuego fuerte. Salpimentar. Reducir a fuego moderado y cocer durante 10 minutos sin darle la vuelta. Precalentar otra sartén y agregar el resto del aceite de oliva. Saltear el ajo, los tomates cherry, las cebollas, el chalote y el pimentón.
Emplatado: En un plato, disponer un fondo de puré de patata y judías verdes y colocar el pescado en el centro. Agregar los tomates, las cebollas y el ajo salteados.

Belga Queen

Design: Antoine Pinto | Chef: Xavier Aldon

Rue Fossé aux Loups 32 | 1000 Brussels
Phone: +32 2 217 21 87
www.belgaqueen.be
Subway: De Brouckère
Opening hours: Mon–Sun from noon to 2:30 pm, from 7 pm to midnight
Average price: € 40
Cuisine: Refined Belgian brasserie with authentic Belgian beers
Special features: Downstairs club (livemusic on Thursday and Friday, DJ sets on
Thursday); Oyster Bar in a previous bank building

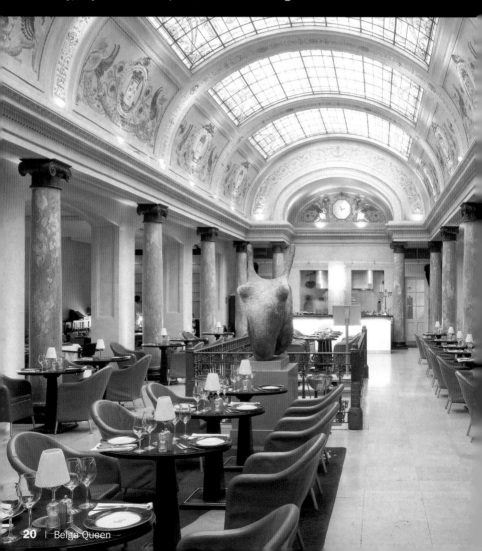

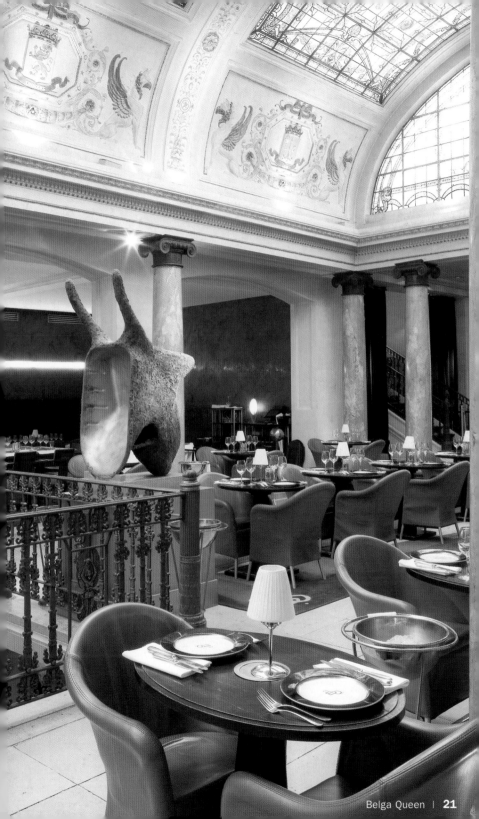

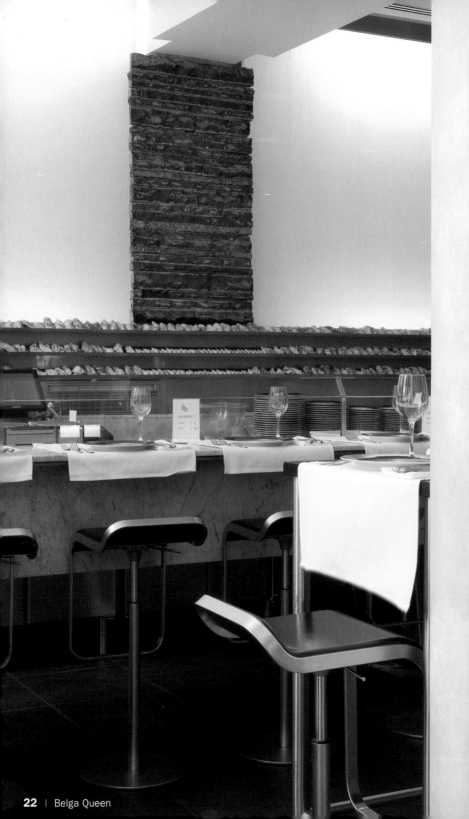

Poulet de Malines

au four sur pain de gingembre au sirop de poire

Geroosterd Mechels hoen op kruidkoek
met perensiroop

Roast Malines Chicken on Gingerbread
with Pear Syrup

Brüssler Poularde gebacken auf
Ingwerbrot mit Birnensirup

Pollo de Malines al horno sobre
pan de jengibre al sirope de pera

1 poulet de Malines
1 pain de gingembre
2 pommes de terres
Sel et poivre
45 ml d'huile d'olive
4 échalotes finement émincées
1 gousse d'ail
1 feuille de laurier frais
1 brin de thym frais
Sel de Guérande
Poivre moulu
200 ml de bouillon de poule
30 ml de sirop de poire
200 ml de bière de framboise
Beurre fermier

Séparer les morceaux de poulet et garder uniquement les cuisses et le blanc. Assaisonner et faire cuire d'un côté avec 15 ml de l'huile d'olive jusqu'à ce que la peau soit croustillante. Faire griller le blanc au four à 180 °C pendant 8 minutes et les cuisses pendant 18 minutes. Pour préparer la sauce, mettre dans une poêle, l'ail, le thym et le laurier et faire cuire à feu doux. Ajouter le sel de Guérande et le poivre. Incorporer la bière de framboise. Réduire. Ajouter le bouillon de poule et faire bouillir pendant quelques minutes de plus. Ajouter le sirop de poire et faire la sauce. Fouetter avec le beurre farmier. Couper 3 triangles de pain de gingembre et les enduire de sirop de poire. Couper les pommes de terre en tranches fines et frire à 180 °C.
Presentation : Disposer le poulet sur une assiette rectangulaire et arroser de sirop. Accompagner de triangles de pain de gingembre et les pommes de terre.

1 Mechels hoen of grote kip
1 kruidkoek
2 aardappelen
Zout en peper
45 ml olijfolie
4 fijngehakte sjalotjes
1 teentje knoflook
1 vers laurierblad
1 takje verse tijm
Grof zeezout
Gemalen peper
200 ml kippenbouillon
30 ml perensiroop
200 ml frambozenbier
Boerenboter

Snijd de kip in stukken. U gebruikt alleen de poten en de borst. Bestrooi ze met zout en peper, en bak ze aan één kant in 15 ml olijfolie tot het vel knapperig is. Bak de borst 8 minuten in de oven op 180 °C en de poten 18 minuten. Doe voor de saus sjalotjes, knoflook, tijm en laurierblad in een pan met dikke bodem en fruit op een laag vuur. Voeg zeezout en peper toe. Schenk het frambozenbier erbij en laat inkoken. Schenk de kippenbouillon erbij en laat een paar minuten doorkoken. Voeg de perensiroop toe en zeef de saus. Klop er wat boerenboter door. Snijd 3 driehoekjes kruidkoek en laat ze weken in perensiroop. Snijd de aardappelen in dunne plakjes en bak ze op 180 °C.
Serveren: Leg de kipdelen op een vierkant bord en giet de saus erover. Dien op met de driehoekjes kruidkoek en de aardappelen.

1 Malines chicken
1 Gingerbread
2 Potatoes
Salt and pepper
45 ml olive oil
4 finely chopped shallots
1 garlic clove
1 fresh bay leaf
1 sprig of fresh thyme
Guérande salt
Ground pepper
200 ml chicken broth
30 ml pear syrup
200 ml raspberry flavored beer
Farm Butter

Separate the parts of the chicken and use only the thighs and the breast. Add salt and pepper, and sauté on one side in 15 ml olive oil until the skin is crunchy. Bake the breast in the oven at 350 °F for 8 minutes and the thighs for 18 minutes. To prepare the sauce put the shallots, the garlic, the thyme, and the bay leaf in a frying pan and cook on a low heat. Add the Guérande salt and pepper. Pour in the raspberry beer. Reduce. Add the chicken broth and boil for a few more minutes. Add the pear syrup and strain the sauce. Beat together with farm butter. Cut 3 triangles of gingerbread and soak them with the pear syrup. Cut the potatoes into thin slices and fry at 350 °F.
To serve: Place the chicken on a square plate and drench with the syrup. Accompany with the gingerbread triangles and the potatoes.

1 Brüssler Poularde
1 Ingwerbrot
2 Kartoffeln
Salz und Pfeffer
45 ml Olivenöl
4 fein gehackte Schalotten
1 Knoblauchzehe
1 frisches Lorbeerblatt
1 Zweig frischer Thymian
Guérande-Meersalz
Gemahlener Pfeffer
200 ml Hühnerbrühe
30 ml Esslöffel Birnensirup
200 ml Himbeerbier
Butter

Die Hähnchenteile ausnehmen und nur die Hähnchenschenkel und die Brust aufbewahren. Salzen, pfeffern und von einer Seite in 15 ml Olivenöl anbraten, bis die Haut knusprig ist. Die Hähnchenbrust im Backofen bei 180 °C 8 Minuten backen und die Schenkel 18 Minuten. Für die Sauce die Schalotten, den Knoblauch, Thymian und den Lorbeer in eine Pfanne geben und auf niedriger Flamme kochen. Das Guérande-Meersalz und den Pfeffer hinzugeben. Das Himbeerbier hinzugeben. Aufkochen lassen. Die Hühnerbrühe hinzugeben und ein paar Minuten länger kochen lassen. Den Birnensirup hinzugeben, die Sauce abseihen und mit Butter schlagen. 3 Dreiecke aus dem Ingwerbrot schneiden und mit Birnensirup bestreichen. Die Kartoffeln in feine Scheiben schneiden und bei 180 °C frittieren. Serviervorschlag: Das Hähnchen auf einen viereckigen Teller geben und mit dem Sirup begießen. Die Ingwerbrotdreiecke und die Kartoffeln hinzugeben.

1 pollo de Malines
1 pan de jengibre
2 patatas
Sal y pimienta
45 ml de aceite de oliva
4 chalotes cortados muy finos
1 diente de ajo
1 hoja de laurel fresco
1 ramita de tomillo fresco
Sal de Guérande
Pimienta molida
200 ml de caldo de pollo
30 ml de sirope de pera
200 ml de cerveza de frambuesa
Mantequilla

Separar las partes del pollo y conservar únicamente los muslos y la pechuga. Salpimentar y cocer por un lado con 15 ml de aceite de oliva hasta que la piel esté crujiente. Asar la pechuga en el horno a 180 °C durante 8 minutos y los muslos durante 18 minutos. Para preparar la salsa, introducir en una sartén los chalotes, el ajo, el tomillo y el laurel y cocer a fuego lento. Agregar la sal de Guérande y la pimienta. Incorporar la cerveza de frambuesa. Reducir. Añadir el caldo de pollo y hervir durante unos minutos más. Agregar el sirope de pera y colar la salsa. Batir con la mantequilla. Cortar 3 triángulos de pan de jengibre y untarlos con el sirope de pera. Cortar las patatas en láminas finas y freír a 180 °C.
Emplatado: Disponer el pollo en un plato rectangular y regar con el sirope. Acompañar con los triángulos de pan de jengibre y las patatas.

Bo Zar Resto

Design: Jan de Cock

Rue Ravenstein 23 | 1000 Brussels
Phone: +32 2 507 85 85
www.bozar.be
Subway: Gare Centrale, Park
Opening hours: Tue–Sun from 9:30 am to 11:00 pm
Average price: € 12
Cuisine: Creative with Asian, French and Italian touches
Special features: A Jan de Cock's art creation using conglomerate wooden frames

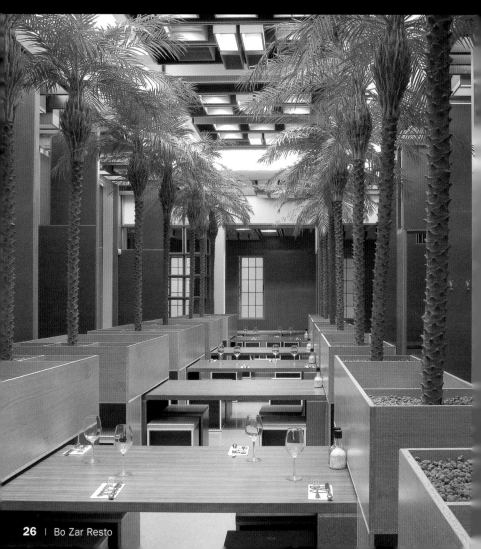

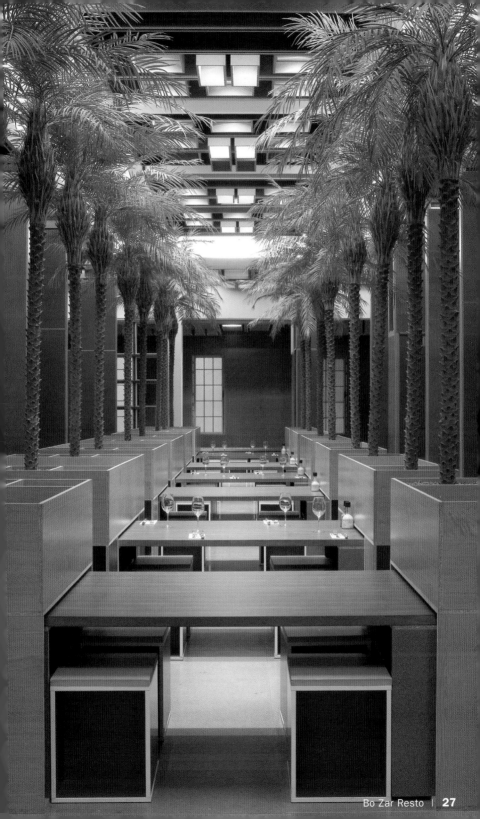

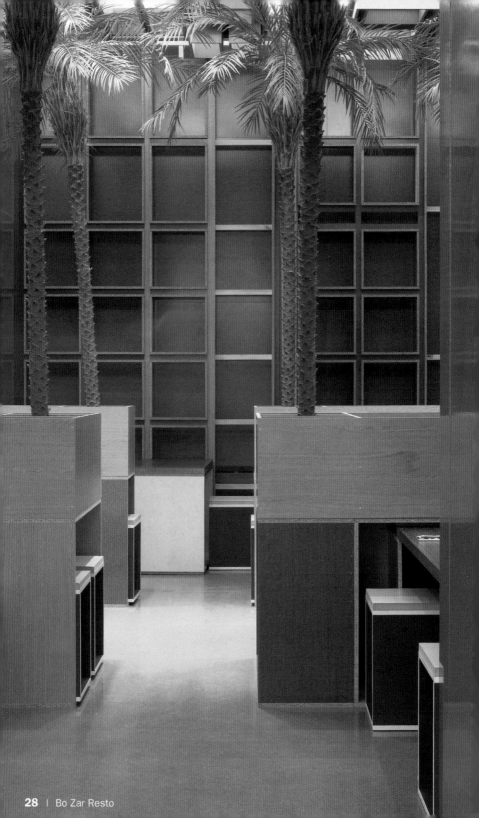

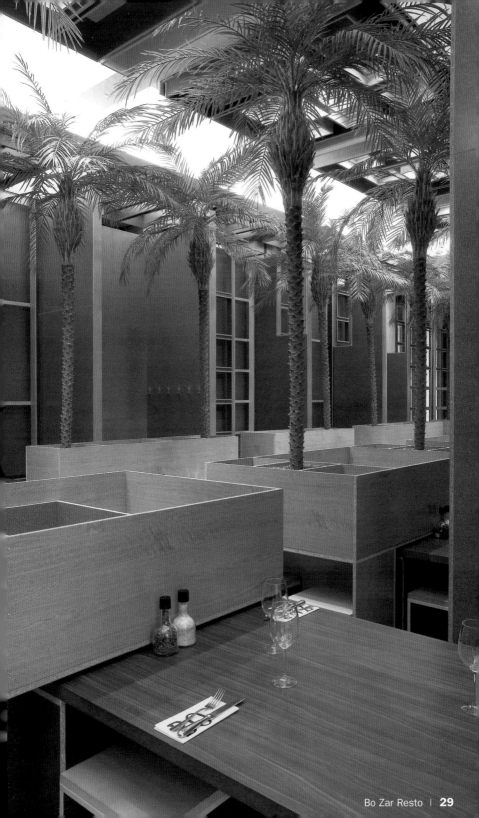

Tartare de bœuf

Steak Tartare

Steak Tartar

Tatar vom Rind

Tartar de buey

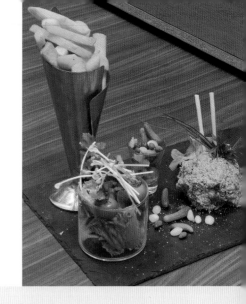

600 g de viande de bœuf
50 g de cornichons
50 g d'oignons tendres
4 gouttes de sauce anglaise
2 gouttes de Tabasco
2 g de coriandre émincée
Une pincée de moutarde
2 g de concentré de tomate
15 g de mayonnaise
Poivre moulu
Sel
60 g de frites
Salade

Émincer finement la viande et mélanger avec le concentré de tomate et coriandre. Ajouter la sauce anglaise et le Tabasco et mélanger à la fourchette.
Presentation: Disposer la viande sur une assiette et placer tout autour une garniture de cornichons et d'oignons. Servir à part le sel et le poivre pour que chacun puisse assaisonner le plat à sa guise. Accompagner d'un cornet de frites et d'un salade.

600 g biefstuk
50 g augurkjes
50 g lente-uitjes gehakt
4 druppels Worcestershiresaus
2 druppels tabasco
2 g gehakte koriander
Een snufje mosterd
2 g tomatenpuree
15 g mayonaise
Gemalen peper
Zout
60 g zakje friet
Salade

Hak de biefstuk fijn en meng met tomatenpuree en koriander. Voeg de Worcestershiresaus en tabasco toe en meng met een vork.
Serveren: Leg de gehakte biefstuk op een bord en schik de augurkjes en uitjes eromheen als garnering. Serveer zout en peper apart zodat iedereen de biefstuk zelf op smaak kan brengen. Dien op met een zakje friet en een salade.

21 oz beefsteak
1 1/2 oz pickles
1 1/2 oz spring onions
4 drops of Worcestershire sauce
2 drops of Tabasco sauce
A pinch of chopped cilantro
A pinch of mustard
A pinch of tomato paste
1/2 oz mayonnaise
Ground pepper
Salt
2 oz French fries
Salad

Finely chop the steak and mix with the tomato paste and cilantro. Add the Worcestershire and Tabasco sauces and mix together with a fork. To serve: Put the steak on a plate and place the pickles and spring onions around it as a garnish. Serve the salt and pepper separately so that each person can season to taste. Accompany with a paper cone of fried potatoes and a salad.

600 g Rindfleisch
50 g saure Gurken
50 g Frühlingszwiebeln
4 Tropfen Worcestersauce
2 Tropfen Tabasco
2 g gehackter Koriander
Etwas Senf
2 g Tomatenmark
15 g Mayonnaise
Gemahlener Pfeffer
Salz
60 g Pommes frites
Salat

Das Fleisch fein hacken und mit dem Tomatenmark und dem Koriander vermengen. Die Worcestersauce und den Tabasco hinzugeben und mit einer Gabel unterheben. Serviervorschlag: Das Fleisch auf den Teller legen und um das Fleisch die sauren Gurken und die Frühlingszwiebeln dekorieren. Salz und Pfeffer extra servieren, damit sich jeder Gast sein Gericht nach Belieben würzen kann. Als Beilage Pommes frites und Salat servieren.

600 g de carne de buey
50 g de pepinillos
50 g de cebolletas
4 gotas de salsa inglesa
2 gotas de tabasco
2 g cilantro picado
Una pizca de mostaza
2 g de concentrado de tomate
15 g de mayonesa
Pimienta molida
Sal
60 g de patatas fritas
Ensalada

Picar finamente la carne y mezclar con el concentrado de tomate y el cilantro. Agregar la salsa inglesa y el tabasco y mezclar con la ayuda de un tenedor. Emplatado: Disponer la carne en un plato y colocar alrededor, como guarnición, los pepinillos y las cebolletas. Servir aparte la sal y la pimienta para que cada comensal aderece el plato a su gusto. Acompañar con un cornete de patatas fritas y ensalada.

Bonsoir Clara

Design: Frédéric Nicolay | Chef: Carl Henaux

Rue Antoine Dansaert 22 | 1000 Brussels
Phone: +32 2 502 09 90
www.bonsoirclara.be
Subway: Bourse, Ste. Catherine
Opening hours: Mon–Sun from noon to 2:30 pm, and from 7 pm to 11:30 pm (Friday and Saturday until midnight), closed on Saturday and Sunday at lunch time
Average price: € 40
Cuisine: French and Mediterranean
Special features: Colorful mosaic

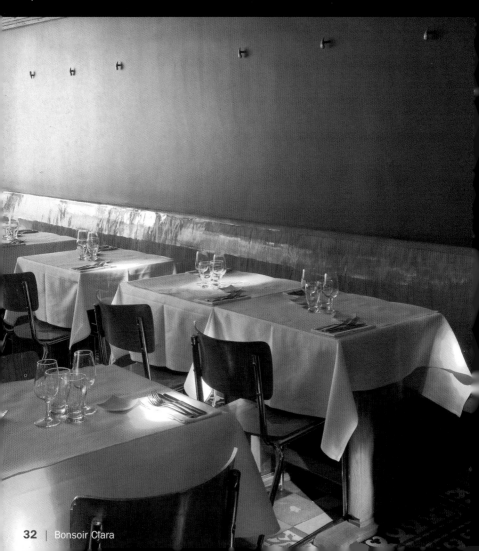

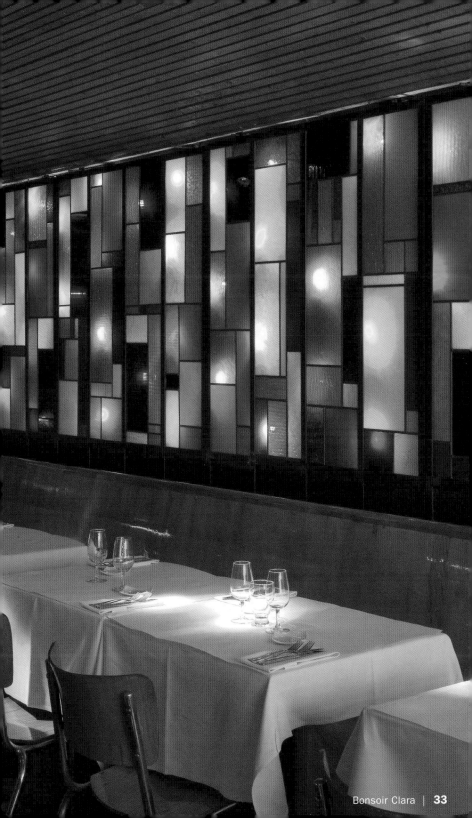

Filet de thon,

« brunoise » de légumes de Nice et gnocchis

Tonijnfilet, 'groentebrunoise' niçoise en nocchi

Filet of Tuna, "Brunoise" of Vegetables Nicoise and Gnocchis

Tunfischfilet, „Brunoise" vom Gemüse aus Nizza und Gnocchis

Filete de atún, "brunoise" de verduras de Niza y gnocchi

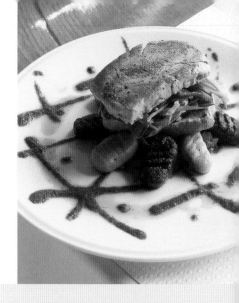

1 filet de thon de 300 g
50 g de carottes
50 g de céleri
50 g de courgette
50 g d'oignon
50 g de poireaux
50 g de haricots verts
50 g de gnocchis de pommes de terre et épinards
5 g de beurre
15 ml d'eau
Thym
Huile d'olive
Sel
Poivre
Purée d'épinards

Couper en petits dés les poireaux, les carottes, le céleri, l'oignon et la courgette. Cuire les légumes verts à feu doux avec huile d'olive et de l'eau. Assaisonner et saupoudrer d'un peu de thym. Réserver, une fois qu'ils sont cuits et que toute l'eau s'est évaporée. Couper les haricots verts en julienne et les bouillir à l'eau avec la beurre. Réserver. Couper le filet de thon en escalopes de 150 g, assaisonner et faire dorer à la poêle avec un peu d'huile pendant quelques minutes. Faire bouillir les gnocchis de pomme de terre et d'épinards. Assaisonner et réserver. Presentation : Disposer au centre d'une grande assiette une couche de « brunoise » de légumes. Mettre au-dessus une des escalopes de thon et la recouvrir de haricots verts. Ajouter pardessus l'autre escalope de thon. Accompagner de gnocchis de pommes de terre et épinards, en les disposant autour des filets de thon. On peut garnir également d'un peu de purée d'épinards.

300 g tonijnfilet
50 g wortel
50 g bleekselderij
50 g courgette
50 g uien
50 g prei
50 g sperziebonen
50 g aardappel spinaziegnocchi
5 g boter
15 ml water
Tijm
Olijfolie
Zout
Peper
Gepureerde spinazie

Snijd wortel, bleekselderij, courgette en prei in kleine stukjes. Bak de groenten in olijfolie en water op een laag vuur. Breng licht op smaak met zout en peper en wat tijm. Zet de groenten opzij zodra ze gaar zijn en het water is verdampt. Snijd de sperziebonen in dunne reepjes en kook ze in water met wat boter. Zet apart. Snijd het stuk tonijn in filets van 150 g, bestrooi ze met zout en peper en bak ze in wat olijfolie in een paar minuten bruin. Kook de aardappel spinaziegnocchi. Breng op smaak en houd ze apart. Serveren: Maak een bedje van de 'groentebrunoise' in het midden van een groot bord. Leg hier de tonijnfilets op en bedek ze met de sperziebonen. Leg de gnocchi om de tonijnfilet. Garneer eventueel met wat gepureerde spinazie.

1/2 lb 3 oz tuna filet
1 3/4 oz carrots
1 3/4 oz celery
1 3/4 oz zucchini
1 3/4 oz onions
1 3/4 oz leeks
1 3/4 oz green beans
1 3/4 oz potato and spinach gnocchi
1 oz butter
15 ml water
Thyme
Olive oil
Salt
Pepper
Pureed spinach

Dice the leeks, carrots, celery, onion, and zucchini. Cook the vegetables olive oil and the water over a low heat. Season with salt and pepper and add a little thyme. When they are done and the water has evaporated put them aside. Cut the green beans in julienne and boil them in water with a small amount of butter. Put aside. Slice the tuna into 5 oz filets, add salt and pepper and brown them in a frying pan with a little oil for a few minutes. Boil the potato and spinach gnocchi. Season and set aside. To serve: Make a bed of the Vegetable "brunoise" in the center of a large plate. Place the tuna filets on top and cover them with the green beans. Accompany with the potato and spinach gnocchi placed around the tuna filets. This can be served with a little spinach puree as a garnish.

1 Tunfischfilet (300 g)
50 g Möhren
50 g Sellerie
50 g Zucchini
50 g Zwiebel
50 g Lauch
50 g Grüne Bohnen
50 g Kartoffel- und Spinatgnocchis
5 g Butter
15 ml Wasser
Thymian
Olivenöl
Salz
Pfeffer
Spinatpüree

Den Lauch, die Möhren, die Sellerie, die Zwiebel und die Zucchini in kleine Würfel schneiden. Das Gemüse auf niedriger Flamme mit je 1 EL Olivenöl und Wasser andünsten. Salzen, pfeffern und etwas Thymian darüber streuen. Die grünen Bohnen in Streifen schneiden und in Wasser mit etwas Butter kochen. Zur Seite stellen. Das Tunfischfilet in Schnitzel zu je 150 g teilen, pfeffern und salzen und in der Pfanne mit wenig Öl ein paar Minuten goldbraun braten. Die Kartoffel- und Spinatgnocchis kochen. Salzen und beiseite stellen.
Serviervorschlag: In der Mitte des Tellers ein Bett aus der „Brunoise" aus Gemüse anrichten. Ein Tunfischschnitzel drauflegen und mit grünen Bohnen bedecken. Darüber ein weiteres Schnitzel legen und die Kartoffel- und Spinatgnocchis um die Tunfischfilets anordnen. Eventuell mit Spinatpüree garnieren.

1 filete de atún de 300 g
50 g de zanahorias
50 g de apio
50 g de calabacín
50 g de cebolla
50 g de puerros
50 g de judías verdes
50 g de gnocchi de patata y espinacas
5 g de mantequilla
15 ml de agua
Tomillo
Aceite de oliva
Sal
Pimienta
Puré de espinacas

Cortar en daditos los puerros, las zanahorias, el apio, la cebolla y el calabacín. Rehogar las verduras a fuego lento con aceite de oliva y el agua. Salpimentar y espolvorear un poco de tomillo. Cortar las judías verdes en juliana y hervirlas en agua con la mantequilla. Reservar. Cortar el filete de atún en escalopes de 150 g, salpimentar y dorar en la sartén con poco aceite durante unos minutos. Hervir los gnocchi de patata y espinacas. Sazonar y reservar.
Emplatado: Disponer en el centro del plato un lecho de "brunoise" de verduras. Colocar encima un escalope de atún y cubrir con las judías verdes. Disponer encima otro escalope y acompañar con los gnocchis de patata y espinacas, situándolos alrededor de los filetes de atún. Decorar con puré de espinacas.

Café Du Vaudeville

Design: Philippe Guillemin | Chef: Bruno Lesbats

Galerie de la Reine 11 | 1000 Brussels
Phone: +32 2 511 23 45
www.cafeduvaudeville.be
Subway: Gare Centrale, Park
Opening hours: Mon–Sat from 9 am to midnight, and Sun from 9 am to 8 pm
Average price: € 12
Cuisine: International and Brussels specialities
Special features: Terrace, menu for groups (from € 22 to € 50)

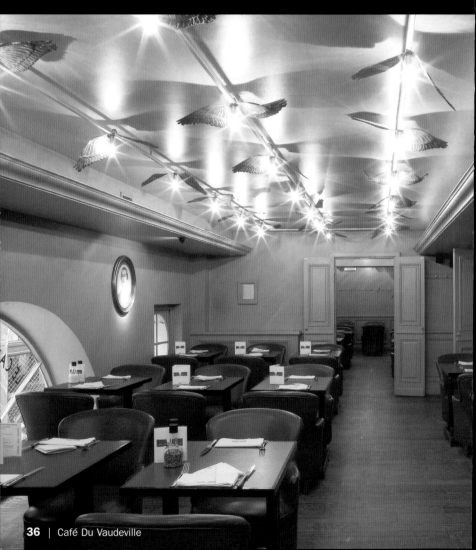

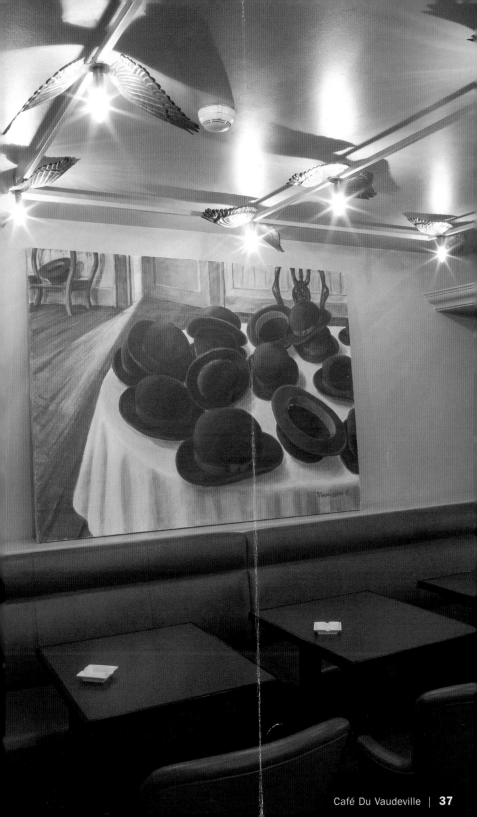

« Bloempanch »

aux pommes de terre et prunes

'Bloempanch' met aardappelen en pruimen
"Bloempanch" with Potatoes and Plums
„Bloempanch" mit Kartoffeln und Pflaumen
"Bloempanch" con patatas y ciruelas

1 « bloempanch »
1 feuille d'endives
3 pommes de terre
2 oignons
10 g de ciboulette
50 g de pruneaux
Sirop de Liège
Persil

Eplucher et cuire les pommes de terre. Dans une poêle, faire dorer les oignons, les pommes de terre, les ciboulettes et le persil. Nettoyer les pruneaux et les couper en petits morceaux. Intégrer les pruneaux à la sauce et les accompagner de sirop de Liège. Couper la saucisse en morceaux et assaisonner les.
Presentation : Dans une assiette chaude, déposer l'endive coupée en fines lamelles, les pommes de terre et la saucisse. Arroser de sauce.

1 'bloempanch' (varkensworst)
1 paar radicchiobladeren
3 aardappelen
2 uien
10 g bieslook
50 g pruimen
Luikse stroop
Peterselie

Schil en kook de aardappelen. Bak in een koekenpan de aardappelen bruin met de bieslook en de peterselie. Maak de pruimen schoon en snijd ze in kleine stukjes. Voeg de pruimen toe aan de saus en schenk er wat Luikse stroop bij. Snijd de worst in stukken en leg deze onder een hete grill.
Serveren: Leg de in reepjes gesneden radicchio op een warm bord met de aardappelen en de worst. Schenk de saus erover.

1 "bloempanch" (pork sausage)
1 radicchio leave
3 potatoes
2 onions
1/3 oz chives
1 3/4 oz plums
Liège syrup
Parsley

Peel and boil the potatoes. In a frying pan brown the potatoes, the chives, and the parsley. Clean the plums and cut them into small pieces. Add the plums to the sauce and accompany with some Liège syrup. Cut the sausage into pieces and grill them.
To serve: Place the radicchio, cut into very thin strips, on a hot plate along with the potatoes and the sausage. Drizzle with the sauce.

1 „bloempanch" (Fleischwurst)
1 Blatt Chicorée
3 Kartoffeln
2 Zwiebeln
10 g Schnittlauch
50 g Pflaumen
.ütticher Sirup
Petersilie

Die Kartoffeln schälen und kochen. In einer Pfanne die Zwiebeln, die Kartoffeln, den Schnittlauch und die Petersilie anbraten. Die Pflaumen waschen und in kleine Stücke schneiden. Die Pflaumen in die Sauce geben und den Lütticher Sirup hinzufügen. Den „bloempanch" in Stücke schneiden und braten.
Serviervorschlag: Auf einem heißen Teller den in feine Scheiben geschnittene Chicorée, die Kartoffeln und die Wurst geben. Mit der Sauce begießen.

1 "bloempanch" (salchicha de carne de cerdo)
1 hoja de achicoria
3 patatas
2 cebollas
10 g de cebollino
50 g de ciruelas
Sirope de Liège
Perejil

Pelar y cocer las patatas. En una sartén, dorar las cebollas, las patatas, los cebollinos y el perejil. Limpiar las ciruelas y cortarlas en trozos pequeños. Incorporarlas a la salsa y agregar el sirope de Liège. Cortar la salchicha en trozos y asarlos.
Emplatado: En un plato caliente, disponer la achicoria cortada en láminas muy finas, las patatas y la salchicha. Regar con la salsa.

Callens Café

Design: Olivier Callens | Chef: Jean Callens

Avenue Louise 480 | 1050 Brussels
Phone: +32 2 647 66 68
www.callenscafe.be
Subway: Louise
Opening hours: Mon–Sun from 7:30 am to 11:30 pm
Average price: € 25
Cuisine: Belgian
Special features: Quick lunches served in 5 minutes

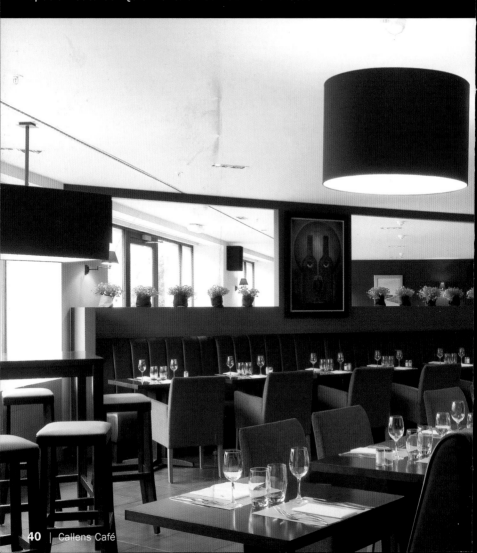

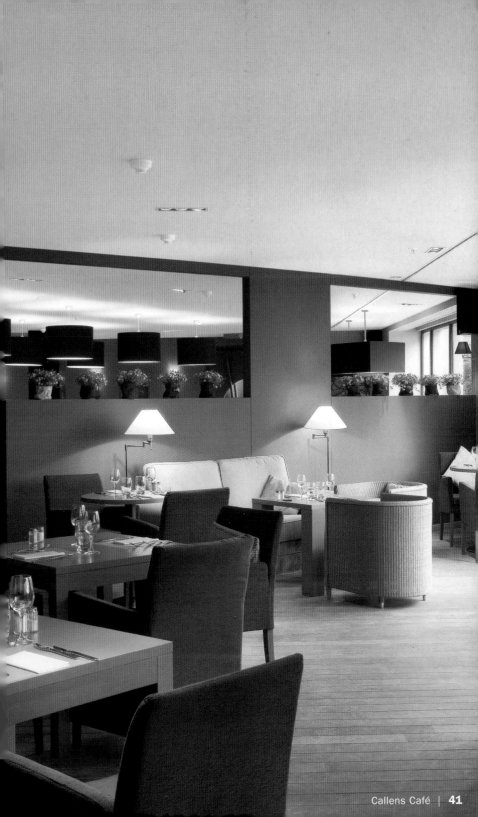

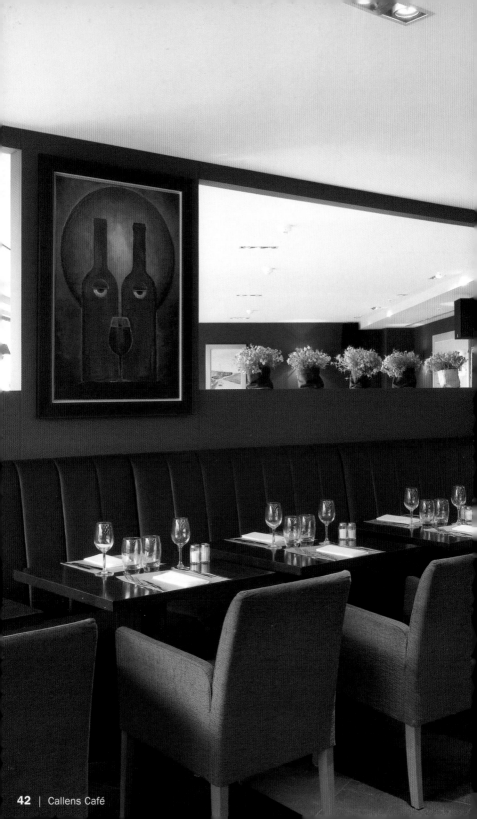

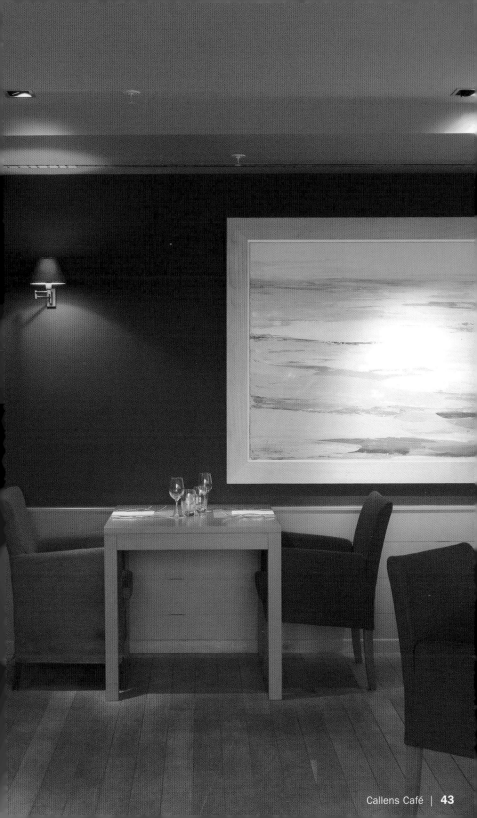

Comme Chez Soi

Design: Mahieu | Chef: Pierre Wynants, Lionel Rigolet

Place Rouppe 23 | 1000 Brussels
Phone: +32 2 512 29 21
www.commechezsoi.be
Subway: Anneessens
Opening hours: Mon–Sat from noon to 1:30 pm, and from 7 pm to 9:30 pm
Average price: € 90
Cuisine: Creative French and Belgian cuisine
Special features: 3 Michelin stars since 1979, Art Nouveau decor in the main room. Table d'hôtes for groups in the kitchen

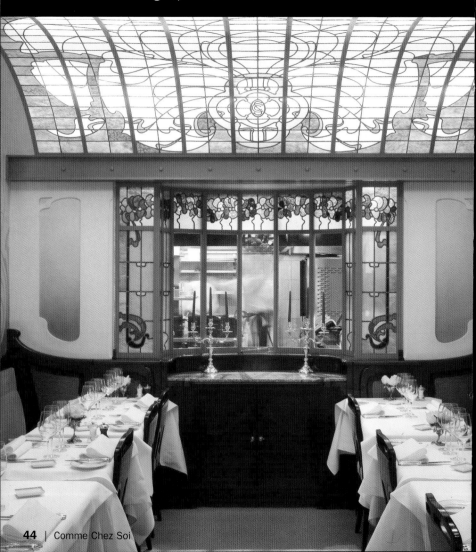

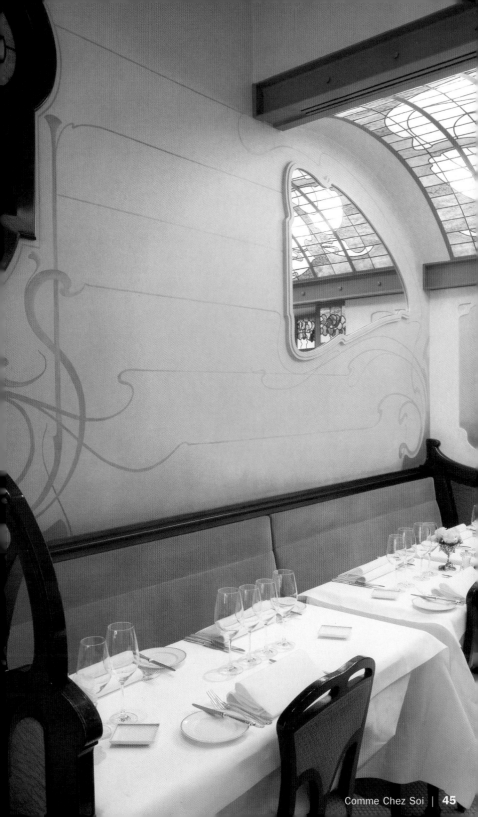

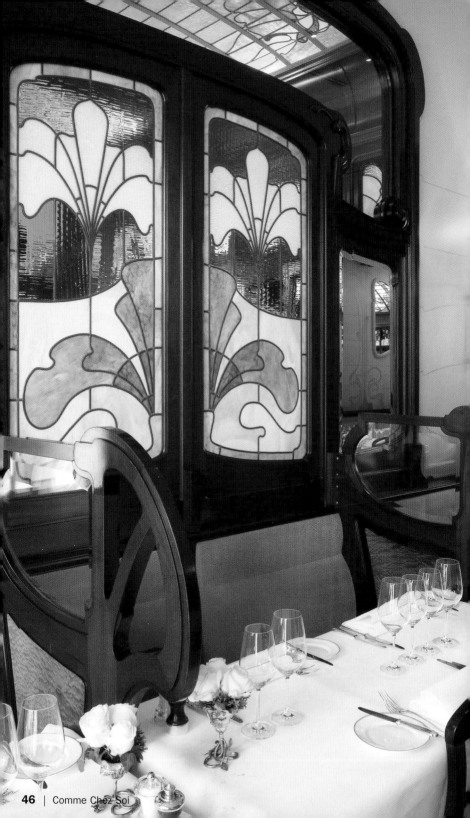

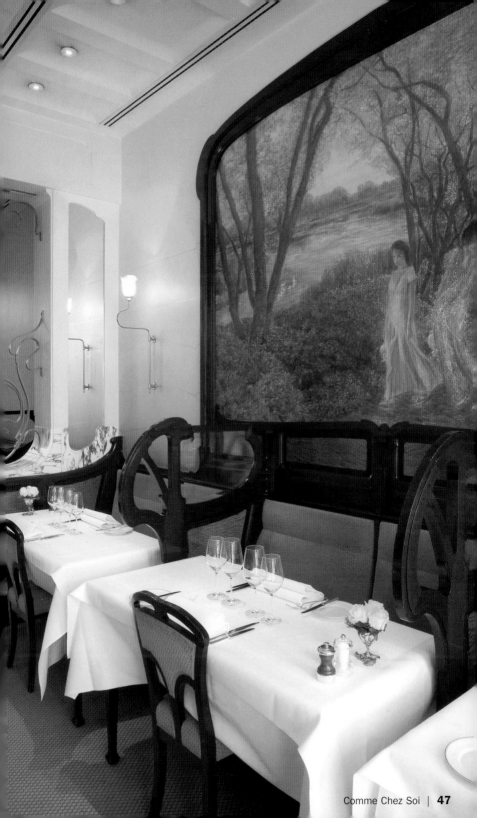

Comocomo

Design: Sebastián Sánchez-Pena | Chef: Ramiro Sánchez-Pena

Rue Antoine Dansaert 19 | 1000 Brussels
Phone: +32 2 503 03 30
www.comocomo.com
Subway: Bourse
Opening hours: Mon–Sun from noon to 3 pm, and from 7 pm to 11 pm
Average price: € 15–25
Cuisine: Basque "montaditos"
Special features: The traditional Basque cuisine presented in the style of sushi
conveyor belt. Wine-chillout-tasting (7 wines, 7 "montaditos") on the first Tuesday
each month

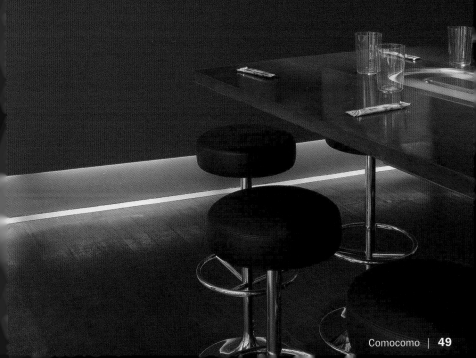

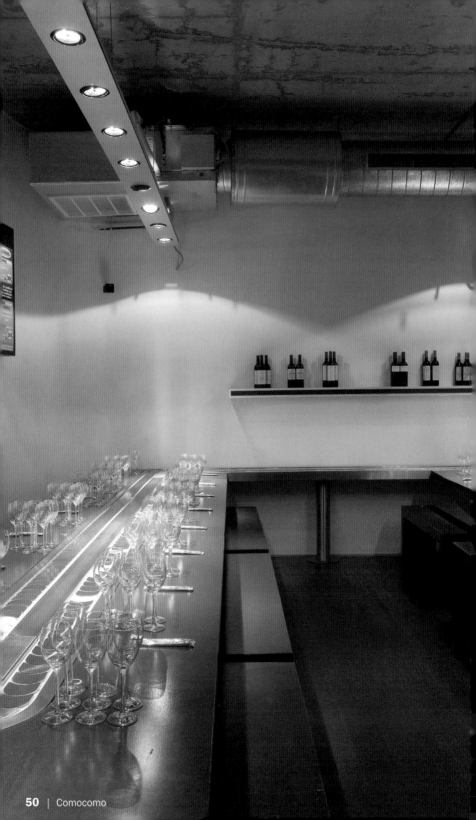

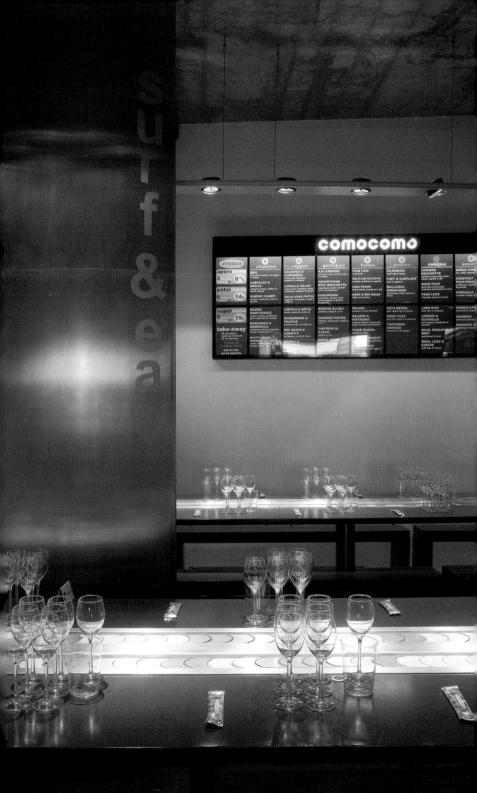

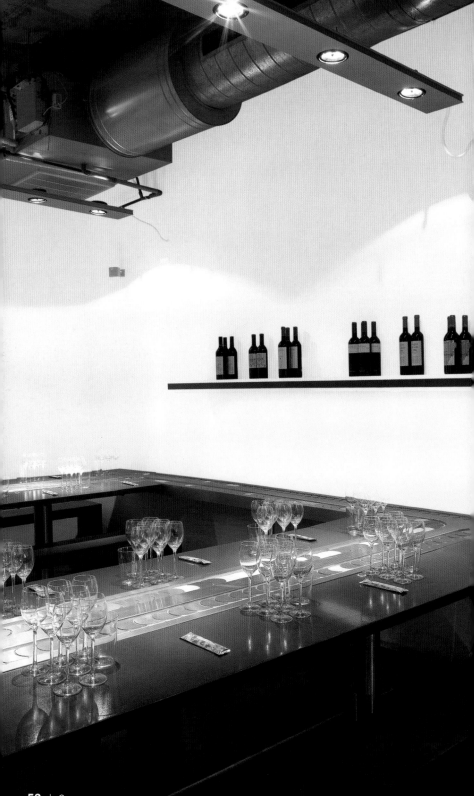

Havana

Design: Michael Ferioli, Nina Rosas | Chef: Nina Rosas

Rue de l'Epée 4 | 1000 Brussels
Phone: +32 2 502 12 24
www.havana-brussels.com
Subway: Louise
Opening hours: Wed from 7 pm to 3 am, Thu from 7 pm to 4 am, Fri–Sat from 7 pm to 7 am
Average price: € 25–35
Cuisine: Spanish and Tex-Mex
Special features: Terrace, DJs every night, livemusic on Wednesdays, transforms into a disco after dinner service

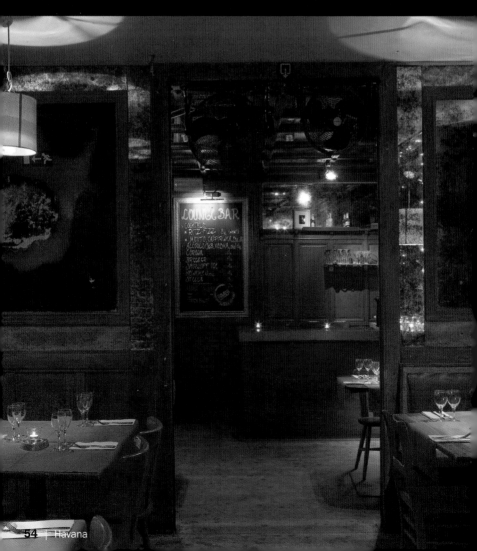

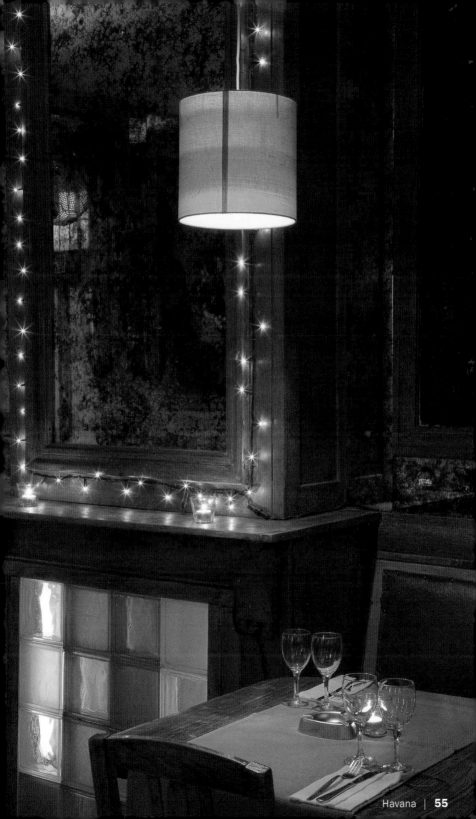

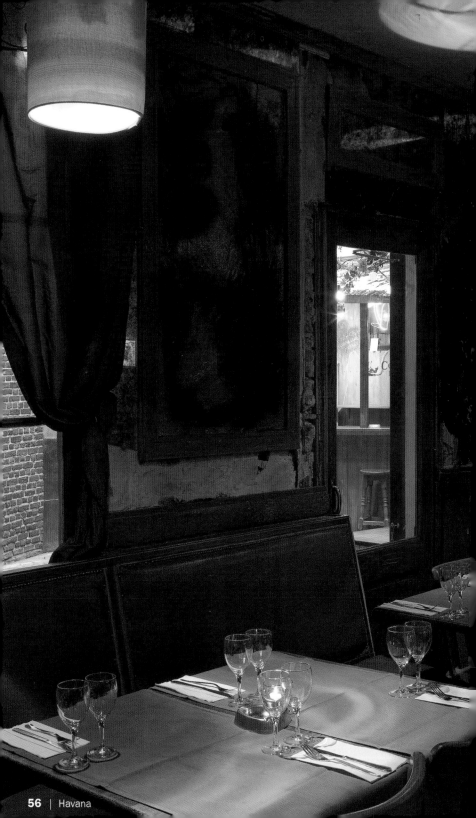

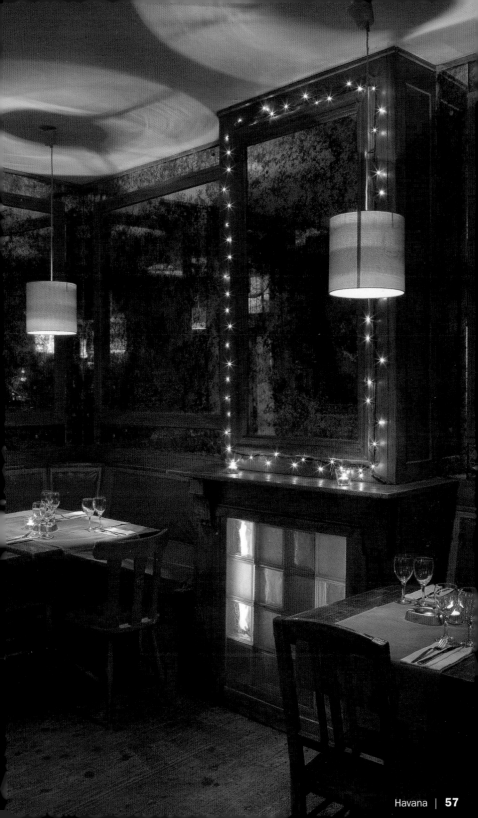

« Fajitas » de poulet

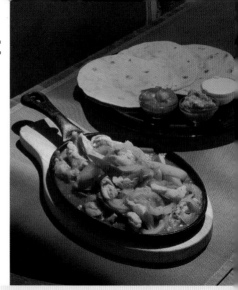

Kipfajitas
Chicken Fajitas
Hähnchen-Fajitas
Fajitas de pollo

300 g de poulet
2 oignons
1 poivron rouge
1 poivron vert
1 poivron jaune
3 tomates fraîches
Paprika
Thym
Romarin
Poudre de chili
1 feuille de basilic
Huile d'olive
Sel
5 omelettes de farine

Couper les oignons et les poivrons en lanières. Couper le poulet en lamelles et faire mariner avec le thym, le romarin, le paprika et le poudre de chili. Laisser reposer pendant 30 minutes et saler et poivrer. Écraser les tomates fraîches, les couler dans une poêle avec un jet d'huile d'olive et les laisser reposer. Avant de retirer, saler et ajouter 1 feuille de basilic. Frire le poulet au gril, donc le passer à une poêle avec l'huile; y ajouter les légumes et, en dernier, la sauce tomate. Cuire pendant 10 minutes à feu lent. Présentation : Servir la « fajita » sur une assiette chaude et accompagner avec des omelette de farine, préalablement réchauffées au four.

300 g kip
2 uien
1 rode paprika
1 groene paprika
1 gele paprika
3 tomaten
Paprikapoeder
Tijm
Rozemarijn
Chillipoeder
1 blaadje basilicum
Olijfolie
Zout
5 bloemtortilla's

Snijd de uien en paprika's in dunne reepjes. Snijd de kip in reepjes en bestrooi met de tijm, rozemarijn en het chilipoeder en paprikapoeder. Laat een half uurtje staan en voeg dan zout en peper toe. Hak de tomaten heel fijn en doe ze in een pan met wat olijfolie en laat ze inkoken. Voeg zout en de basilicum toe voor u de pan van het vuur haalt. Bak de kip in een grillpan en doe de reepjes dan over in een pan met olijfolie, voeg de groenten toe en tot slot de tomatensaus. Bak 10 minuten op een laag vuur. Serveren: Schep de fajita op een heet en dien op met een in de oven verwarmde bloemtortilla.

1/2 lb 3 oz chicken
2 onions
1 red pepper
1 green pepper
1 yellow pepper
3 fresh tomatoes
Paprika
Thyme
Rosemary
Chilli powder
1 basil leaf
Olive oil
Salt
5 flour tortillas

Thinly slice the onions and peppers. Cut the chicken in strips and coat with thyme, rosemary, chilli powder and paprika. Allow it to rest 30 minutes and add salt and pepper. Grind the fresh tomatoes and place inside a pan with a bit of olive oil until reduced, adding salt and a basil leaf before removing from heat. Grill the chicken and place inside a pan with olive oil, add the vegetables, and finally, the tomato sauce. Cook for 10 minutes on low heat.
To serve: Place the fajita on a hot plate and accompany with previously oven-heated flour tortillas.

300 g Hähnchenfleisch
2 Zwiebeln
1 rote Paprikaschote
1 grüne Paprikaschote
1 gelbe Paprikaschote
3 frische Tomaten
Paprikapulver
Thymian
Rosmarin
Chilipulver
1 Basilikumblatt
Olivenöl
Salz
5 Maismehltortillas

Die Zwiebeln und die Paprika in Streifen schneiden. Das Hähnchen in Streifen schneiden und mit Thymian, Rosmarin, Paprikapulver und Chilipulver würzen. 30 Minuten ruhen lassen, salzen und pfeffern. Die frischen Tomaten zerkleinern, mit einem Spritzer Olivenöl in eine Pfanne geben und einkochen lassen. Bevor man die Sauce vom Feuer nimmt, salzen und ein Basilikumblatt hinzufügen. Das Hähnchen grillen, danach mit etwas Öl in eine Pfanne geben, das Gemüse und zuletzt die Tomatensauce hinzugeben. 10 Minuten lang bei niedriger Hitze kochen.
Serviervorschlag: Die Fajita auf einem warmen Teller mit zuvor im Ofen erwärmten Maismehltortillas als Beilage servieren.

300 g de pollo
2 cebollas
1 pimiento rojo
1 pimiento verde
1 pimiento amarillo
3 tomates frescos
Pimentón
Tomillo
Romero
Guindilla en polvo
1 hoja de albahaca
Aceite de oliva
Sal
5 tortillas de harina

Cortar las cebollas y los pimientos en juliana. Cortar el pollo en tiras y adobar con el tomillo, el romero, el pimentón y la guindilla en polvo. Salpimentar y dejar reposar durante 30 minutos. Triturar los tomates frescos, verterlos en una sartén con un chorro de aceite de oliva y dejarlos reducir; antes de retirar, salar y añadir una hoja de albahaca. Asar el pollo a la parrilla, luego pasarlo a una sartén con aceite y añadir las verduras y la salsa de tomate; cocer durante 10 minutos a fuego lento.
Emplatado: Servir las fajitas en un plato caliente y acompañar con las tortillas de harina previamente calentadas en el horno.

Il Passatempo

Design: Giuseppe Zizza | Chef: Angelo Fogler

Rue de Namur 32 | 1000 Brussels
Phone: +32 2 511 37 03
Subway: Porte de Namur
Opening hours: Mon–Sun from noon to 4 pm, from 7:30 pm to 10:30 pm
Average price: € 20–30
Cuisine: Innovative Italian
Special features: Very small but cosy place with a great selection of wines

Tagliolini

à la truffe au beurre et à la sauce

Truffel Tagliolini met boter en salie
Truffle Tagliolini with Butter and Sage
Tagliolini auf Trüffel mit Butter und Salbei
Tagliolini a la trufa con mantequilla y salvia

700 g de tagliolini
250 g de beurre
125 g de bouillon de « boletus edulis »
1 oignon tendre
30 g de pâté de foie d'oie
1 feuille de sauge
Truffe noire ou blanche

Faire dorer l'oignon avec le beurre et la passer au mixeur. Dans cette poêle, ajouter le bouillon, le pâté de foie d'oie et la feuille de sauge. Assaisonner légèrement et remuer à l'aide d'un fouet manuel jusqu'à obtention d'une crème sans grumeaux et veloutée. Cuire la pâte pendant 5 minutes et la filtrer. Mélanger avec la sauce.
Presentation : Disposer la pâte au centre de l'assiette et servir de truffe noire ou blanche (selon la saison).

700 g tagliolini
250 g boter
125 ml bouillon van "boletus edulis"
1 lente-ui
30 g ganzenleverpaté
1 salieblaadje
Zwarte of witte truffel

Fruit de ui bruin in de boter en pureer hem met een staafmixer. Voeg er bouillon, de ganzenleverpaté en het salieblaadje aan toe. Breng licht op smaak met zout en papier en meng met de staafmixer tot een fluweelzachte paté zonder klontjes. Kook de pasta 5 minuten en giet af. Meng de pasta en de saus.
Serveren: schep de pasta in het midden van een bord en dien op met zwarte of witte truffels (afhankelijk van het seizoen).

24 oz tagliolini
8 oz butter
125 ml "boletus edulis" broth
1 spring onion
1 oz goose liver paté
1 sage leaf
Black or white truffle

Brown the onion in the butter and run it through a food mill. In the same frying pan put the broth, the goose liver paté, and a sage leaf. Lightly season with salt and pepper and stir with a hand mixer to make a velvety cream with no lumps. Cook the pasta for 5 minutes and strain it. Mix it with the sauce.
To serve: Put the pasta in the center of the plate and serve with black or white truffle (according to the season).

700 g tagliolini
250 g Butter
125 ml Steinpilz-Brühe
1 Frühlingszwiebel
30 g Gänseleberpastete
1 Salbeiblatt
Schwarze oder weiße Trüffel

Die Frühlingszwiebel in Butter andünsten und mit dem Stabmixer pürieren. Die Steinpilz-Brühe, die Gänseleberpastete und ein Salbeiblatt dazugeben. Leicht salzen, pfeffern und mit einem Handrührgerät rühren, bis eine glatte Creme ohne Klumpen entsteht. Die Nudeln 5 Minuten lang kochen und abseihen. Mit der Sauce mischen.
Serviervorschlag: Die Nudeln in die Mitte des Tellers geben und mit schwarzen oder weißen Trüffeln (je nach Jahreszeit) servieren.

700 g de tagliolini
250 g de mantequilla
125 ml de caldo de "boletus edulis"
 cebolleta
30 g de paté de hígado de oca
 hoja de salvia
trufa negra o blanca

En una sartén, calentar la mantequilla y dorar la cebolleta. Seguidamente, pasarla por el colador. En la misma sartén, agregar el caldo, el paté de hígado de oca y la hoja de salvia. Salpimentar ligeramente y remover con la ayuda de una batidora manual hasta obtener una crema sin grumos y aterciopelada. Cocer la pasta durante 5 minutos y colarla. Mezclar con la salsa.
Emplatado: Disponer la pasta en el centro del plato y servir con trufa negra o blanca (según la estación).

Kasbah

Design: Frédéric Nicolay | Chef: Yussef Ottman

Rue Antoine Dansaert 20 | 1000 Brussels
Phone: +32 2 502 40 26
Subway: Bourse
Opening hours: Mon–Sun from noon to 2:30 pm, and from 7 pm to 11 pm (weekend until 12:30 pm)
Average price: € 30
Cuisine: Moroccan
Special features: A bit of Morocco in Brussels, dark and aromatic place with the warm shades and spices of the North of Africa, decored with multicolored lamps

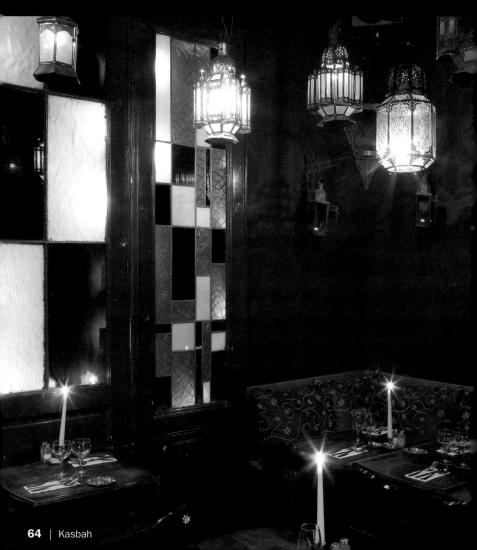

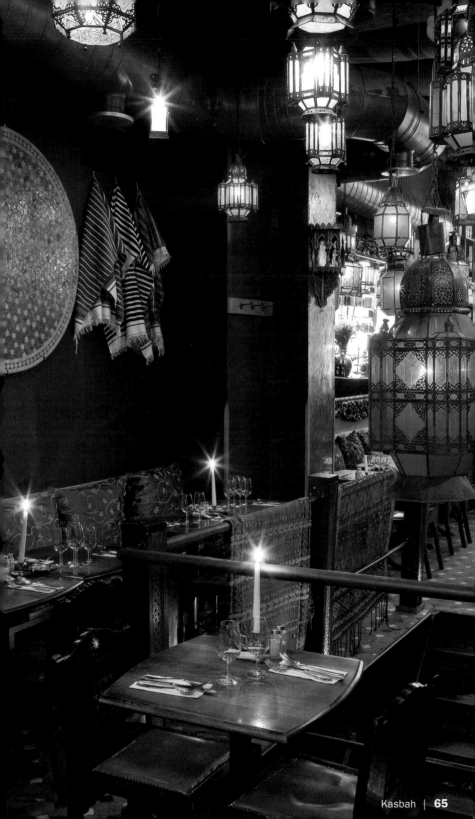

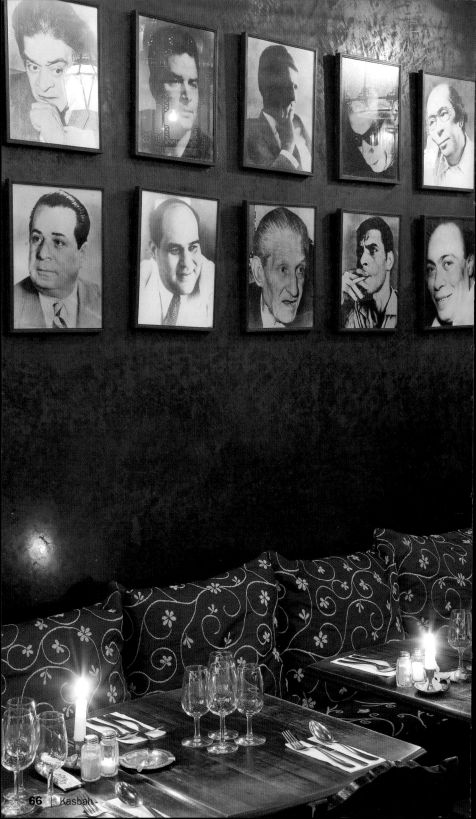

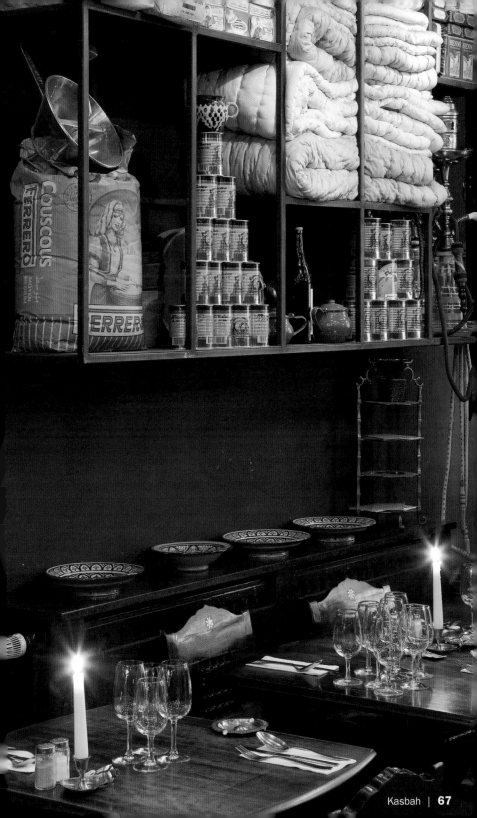

Tajine de mouton

aux pruneaux et amandes

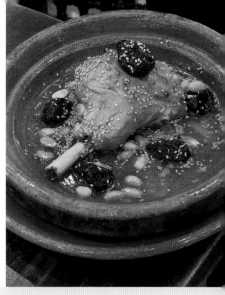

Lamsvleestajine met amandelen en pruimen

Lamb Tajin with Almonds and Plums

Tajin vom Lamm mit Pflaumen und Mandeln

Tajín de cordero con ciruelas y almendras

1 kg d'épaule de mouton en morceaux
500 g de pruneaux secs
1 kg d'oignon
50 g de beurre
125 ml d'huile
1 bâton de cannelle
2 g de cannelle en poudre
2 g cuillère de safran
2 g de gingembre
10 g de graine de sésame grillées
10 g de sucre
100 g d'amandes grillées
Sel

Mettre les pruneaux à tremper à l'eau tiède. Laver et sécher la viande et la disposer dans un bol. Ajouter les épices et le bâton de cannelle. 2 oignons coupés, l'huile et le beurre. Recouvrir d'un litre d'eau. Couvrir et cuire à feu modéré pendant 50 minutes, en remuant de temps à autre et en contrôlant le niveau d'eau. Ajouter le reste des oignons. Egoutter les pruneaux et les ajouter à la cuisson.
Presentation : Disposer la viande sur une assiette et ajouter le sucre et la cannelle en poudre dans le jus avant de recouvrir la viande avec les pruneaux et l'oignon. Saupoudrer de graines de sésame et décorer d'amandes.

1 kg lamsbout in stukken
500 g gedroogde pruimen
1 kg uien
50 g boter
125 ml olie
1 kaneelstokje
2 g gemalen kaneel
2 g saffraan
2 g gemalen gember
10 g geroosterde sesamzaadjes
10 g suiker
100 g geroosterde amandelen
Zout

Week de gedroogde pruimen in warm water. Spoel het lamsvlees af, dep het droog en doe het in de pan. Voeg de specerijen en het kaneelstokje toe, 2 gehakte uien, de olie en boter. Schenk er 1 l water over. Doe het deksel op de pan en laat het geheel 50 minuten op middel hoog vuur sudderen. Roer af en toe door en controleer het waterniveau. Voeg de rest van de ui en toe. Giet de pruimen af en doe ze bij het vlees.
Serveren: Schep het lamsvlees op een bord en voeg de suiker en de kaneel toe aan de saus. Schenk vervolgens de pruimen en uien over het lamsvlees. Bestrooi met sesamzaadjes en garneer met amandelen.

2 lb shoulder of lamb in pieces
1 lb dried plums
2 lb onion
1 3/4 oz butter
125 ml oil
1 cinnamon stick
A pinch of ground cinnamon
A pinch of saffron
A pinch of ginger
1/3 oz toasted sesame seeds
1/3 oz sugar
3 1/3 oz toasted almonds
Salt

Soak the dried plums in warm water. Wash and dry the lamb and put it in a pot. Add the spices and cinnamon stick, 2 chopped onions, the oil, and the butter. Cover with 1 l of water. Put on the lid and cook on medium for 50 minutes, stirring occasionally and checking the water level. Add the rest of the onions. Strain the plums and add them to the pot.
To serve: Put the lamb on a plate and add the sugar and ground cinnamon to the broth before covering the lamb with the plums and onions. Sprinkle with the sesame seeds and garnish with almonds.

1 kg Lammschulter in Stücken
500 g Trockenpflaumen
1 kg Zwiebeln
50 g Butter
125 ml Öl
1 Zimtstange
2 g Zimtpulver
2 g Safran
2 g Ingwer
10 g geröstete Sesamkörner
10 g Zucker
100 g geröstete Mandeln
Salz

Die Pflaumen in lauwarmem Wasser einweichen. Das Fleisch waschen, trocknen und in einen Topf geben. Die Gewürze, die Zimtstange, 2 gehackte Zwiebeln, das Öl und die Butter hinzugeben. Mit 1 l Wasser bedecken und auf mittlerer Flamme 50 Minuten lang kochen. Von Zeit zu Zeit umrühren und die Wassermenge kontrollieren. Den Rest der Zwiebeln hinzugeben. Die Pflaumen abtropfen lassen und in den Topf geben.
Serviervorschlag: Das Fleisch auf einen Teller legen. Zucker und Zimtpulver in die Sauce geben und diese auf dem Fleisch verteilen. Dann die Pflaumen und die Zwiebeln auf das Fleisch legen. Sesamkörner darüber streuen und mit Mandeln dekorieren.

1 kg de paletilla de cordero troceada
500 g de ciruelas secas
1 kg de cebollas
50 g de mantequilla
125 ml de aceite
1 palo de canela
2 g de canela en polvo
2 g de azafrán
2 g de jengibre
10 g de grano de sésamo tostado
10 g de azúcar
100 g de almendras tostadas
Sal

Poner las ciruelas en remojo en agua tibia. Lavar y secar la carne e ponerla en una olla. Añadir las especias y el palo de canela, 2 cebollas cortadas, el aceite y la mantequilla. Cubrir con 1 l de agua. Tapar y cocer a fuego medio durante 50 minutos, removiendo de vez en cuando y comprobando el nivel del agua. Añadir el resto de las cebollas. Escurrir las ciruelas y agregarlas a la cocción.
Emplatado: Disponer la carne en un plato y agregar el azúcar y la canela en polvo al jugo antes de cubrir la carne con las ciruelas y las cebollas. Espolvorear con granos de sésamo y decorar con las almendras troceadas.

Le Khnopff

Design: Miguel Cancio Martins | Chef: Jacques van Dyck

Rue Saint Bernard 1 | 1060 Brussels
Phone: +32 2 534 20 04
www.khnopff.be
Subway: Louise
Opening hours: Mon–Fri from noon to 2:45 pm, from 7 pm to midnight, Sat from
7 pm to midnight, closed on on Sunday
Average price: € 40
Cuisine: French and international fusion
Special features: Terrace, lounge, garden, and livemusic

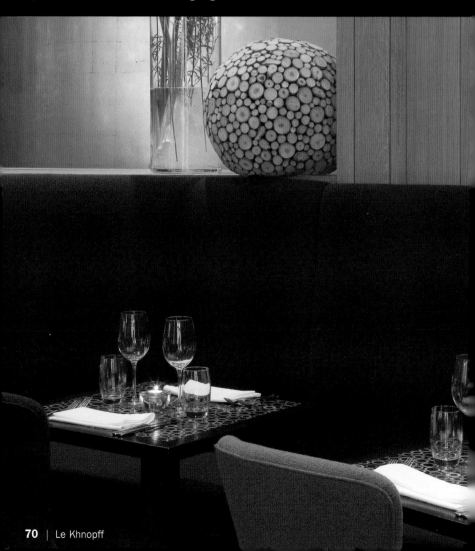

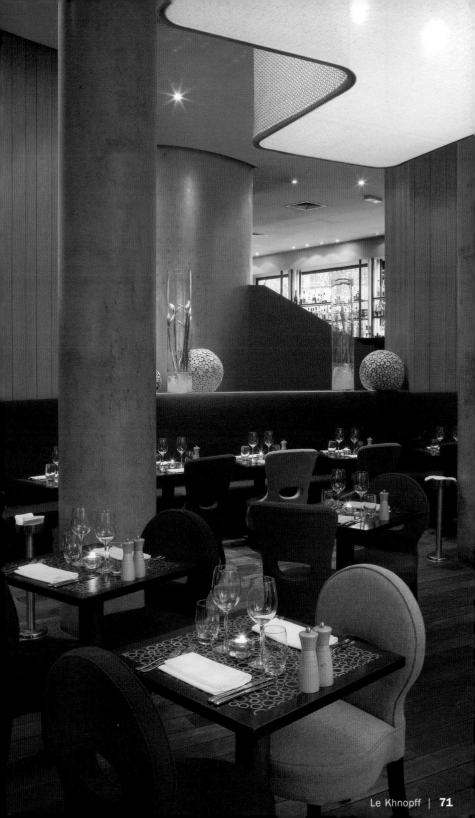

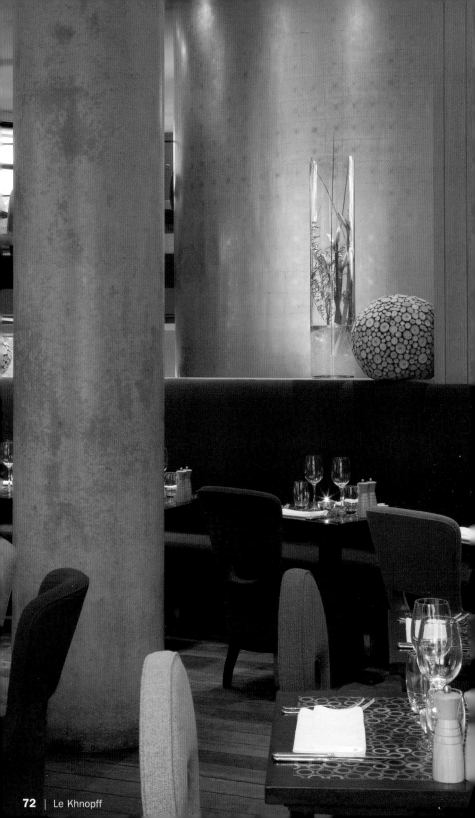

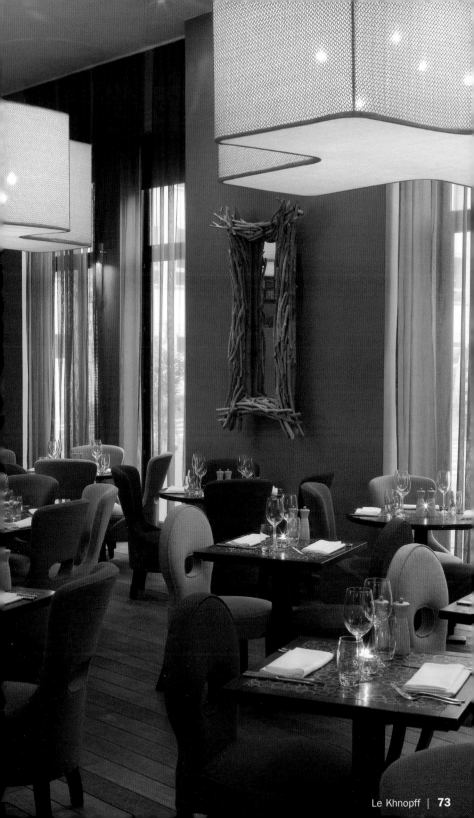

Le Living Room

Design: Ada Design | Chef: Seydina Ba, Christian Dikonda

Chaussée de Charleroi 50 | 1060 Brussels
Phone: +32 2 539 21 11
www.lelivingroom.be
Subway: Louise
Opening hours: Mon–Fri from 7 pm to midnight, Sat–Sun from 7 pm to 2 am
Average price: € 30
Cuisine: International
Special features: Weekly events, clubbing on Saturday with international DJs

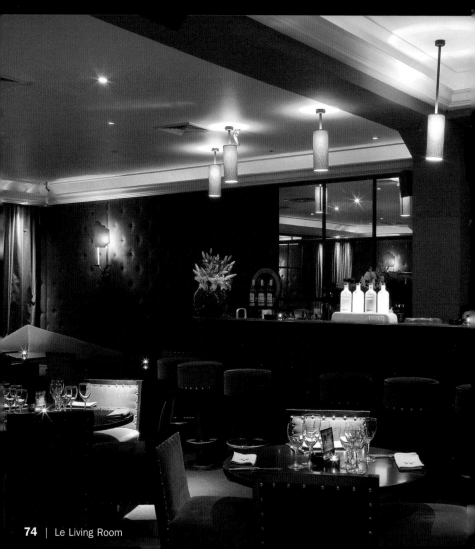

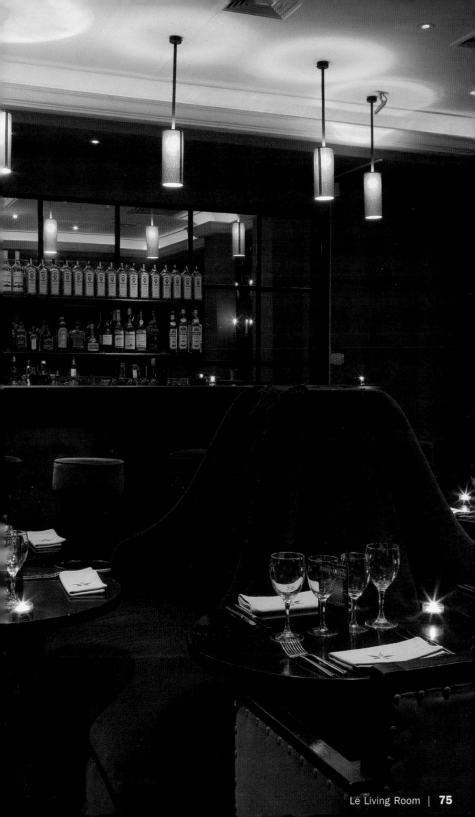

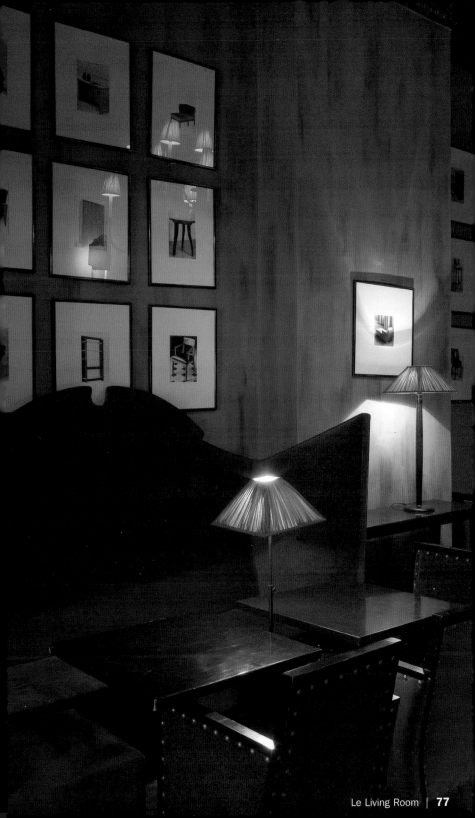

Agneau

à la confiture d'oignon et au Calvados

Lamsvlees met uienmarmelade en calvadossaus

Lamb with Onion Marmalade and Apple Brandy

Lammfleisch mit Zwiebelkonfitüre und Calvados

Cordero con mermelada de cebolla y calvados

2 côtelettes d'agneau
125 ml d'huile d'olive
125 g de moutarde de Dijon en grains
1 brin de romarin frais
8 grains de poivre noir émincés
2 gousses d'ail émincés
Sel et poivre
30 ml de Calvados
500 ml de bouillon d'agneau ou de bœuf
1 gousse d'ail émincée
2 g de romarin frais émincé
100 ml de confiture d'oignon

Mélanger dans un récipient la moutarde, le romarin, les grains de poivre noir et les gousses d'ail. Remuer jusqu'à obtention d'une purée crémeuse. Recouvrir les côtelettes d'agneau entièrement de marinade et mettre au réfrigérateur pendant 12 heures. Préchauffer le four à 190 °C. Faire revenir les côtelettes au four jusqu'à ce qu'elles soient bien dorées. Finir de cuire à la poêle pendant 30 minutes à feu moyen avec l'huile d'olive. Conserver la viande dans du papier d'aluminium pour qu'elle reste chaude. Dans une casserole, porter à ébullition le Calvados et ajouter le bouillon, l'ail et le romarin. Bouillir et réduire à environ 175 ml. Filtrer la sauce et assaisonner.
Presentation : Mettre la viande sur un lit de confiture d'oignon tiède. Arroser de la sauce et servir.

2 lamsracks
125 ml olijfolie
125 g grove dijonmosterd
1 takje verse rozemarijn
8 geplette zwarte peperkorrels
2 gehakte teentje knoflook
Zout en peper
30 ml calvados
500 ml lams- of runderbouillon
1 gehakt teentje knoflook
2 g gehakte, verse rozemarijn
100 ml uienmarmelade

Meng mosterd, rozemarijn, geplette zwarte peper en knoflook in een kom tot een gladde puree. Bestrijk het lamsvlees met het mengsel en laat het op een koele plaats 12 uur rusten. Verwarm de oven voor op 190 °C. Bak het lamsvlees in de oven tot het goudbruin is. Verhit de olijfolie in een koekenpan op middelhoog vuur en bak hierin het lamsvlees nog een half uur op een middelhoog vuur. Wikkel het in aluminiumfolie om het warm te houden. Breng de calvados aan de kook en voeg bouillon, knoflook en rozemarijn toe. Laat inkoken tot ongeveer 175 ml. Zeef de saus en breng op smaak met zout en peper.
Serveren: Leg het vlees op een bedje van de warme uienmarmelade. Druppel de saus erover en dien.

2 racks of lamb
125 ml olive oil
125 g granulated Dijon mustard
1 sprig of fresh rosemary
8 crushed black peppercorns
2 minced garlic cloves
Salt and pepper
30 ml apple brandy
500 ml of lamb or beef broth
1 garlic clove minced
A pinch of chopped fresh rosemary
100 ml onion marmalade

In a bowl mix the mustard, the rosemary, the crushed black pepper, and the garlic. Stir to make a smooth puree. Cover the entire rack of lamb with the mixture and chill for 12 hours. Preheat the oven to 375 °F. Bake the lamb in the oven until it is golden brown. Finish cooking it in a frying pan with olive oil for 30 minutes on medium heat. Wrap the meat in aluminum foil to keep it hot. Bring the apple brandy to boiling in a pot and add the broth, the garlic, and the rosemary. Boil until it is reduced to about 175 ml. Strain the sauce and add salt and pepper.
To serve: Place the meat on a bed of warm onion marmalade. Sprinkle with sauce and serve.

2 Lammrippchen
125 ml Olivenöl
125 g gekörnter Dijonsenf
1 Zweig frischer Thymian
8 gehackte schwarze Pfefferkörner
2 gehackte Knoblauchzehen
Salz und Pfeffer
30 ml Calvados
500 ml Lamm- oder Rindfleischbrühe
1 gehackte Knoblauchzehe
2 g gehackter Rosmarin
100 ml Zwiebelkonfitüre

Den Senf, den Rosmarin, die schwarzen Pfefferkörner und den Knoblauch in einer Schüssel verrühren, bis ein Püree entsteht. Die Lammrippchen mit der Marinade bestreichen und 12 Stunden lang kalt stellen. Den Backofen auf 190 °C vorheizen und die Lammrippchen im Ofen goldbraun backen. Danach die Rippchen in einer Pfanne mit Öl 30 Minuten lang bei mittlerer Hitze fertig braten. Das Fleisch in Aluminiumpapier wickeln, damit es warm bleibt. Den Calvados in einem Topf aufkochen und die Brühe, den Knoblauch und den Rosmarin hinzugeben. Die Sauce bis auf 175 ml reduzieren, abseihen, pfeffern und salzen.
Serviervorschlag: Das Fleisch auf eine Unterlage lauwarmer Zwiebelkonfitüre legen. Mit der Sauce übergießen und servieren.

2 costillares de cordero
125 ml de aceite de oliva
125 g de mostaza de Dijon granulada
1 ramita de romero fresco
3 granos de pimienta negra picados
2 ajos picados
Sal y pimienta
30 ml de calvados
500 ml de caldo de cordero o vaca
1 diente de ajo picado
2 g de romero fresco picado
100 ml de mermelada de cebolla

Mezclar en un recipiente la mostaza, el romero, los granos de pimienta negra y los ajos. Remover hasta obtener una salsa suave. Cubrir los costillares de cordero entero con el adobo y dejar reposar durante 12 horas. Precalentar el horno a 190 °C y asar los costillares hasta que estén dorados. En una sartén, calentar aceite de oliva a fuego medio y acabar de cocinar la carne en la sartén durante 30 minutos a fuego medio. Conservar los costillares en papel de aluminio para que se mantengan calientes. En una cazuela, llevar a ebullición el calvados y añadir el caldo, el ajo y el romero. Hervir hasta que quede reducido a 175 ml aproximadamente. Colar la salsa y salpimentar.
Emplatado: Colocar la carne sobre un lecho de mermelada de cebolla templada. Regar con la salsa y servir.

Le Mess

Design: Pierre Hoet | Chef: Bruno Lesbats

Boulevard Louis Schmidt 1 | 1040 Brussels
Phone: +32 2 734 03 36
www.lemess.be
Subway: Pétillon
Opening hours: Mon–Fri from noon to 2:30 pm, from 7 pm to midnight, closed on
Saturday and Sunday at lunch time
Average price: € 30
Cuisine: French light cuisine
Special features: Terrace, dietetic menu

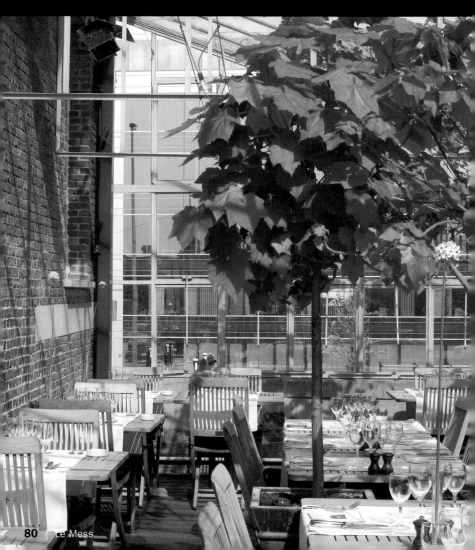

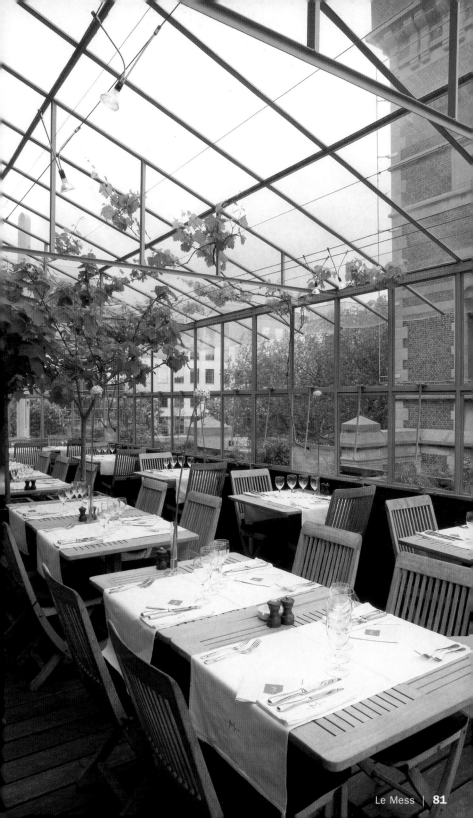

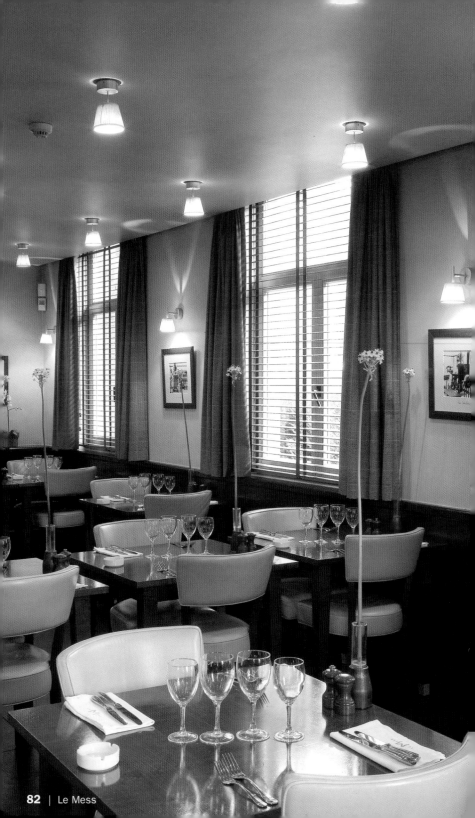

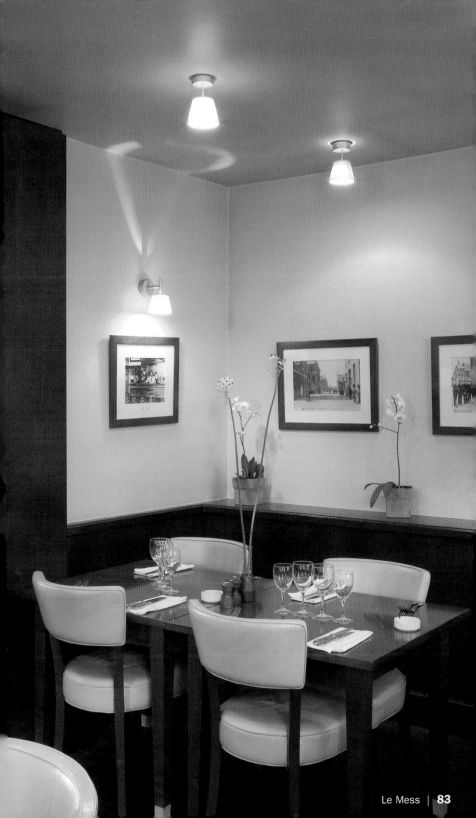

Mille-feuille de thon

avec légumes

Tonijntompouce met groente

Tuna Millefeuille with Vegetables

Mille-feuille mit Tunfisch und Gemüse

Milhojas de atún con verduras

2 filets de thon de 160 g
3 carottes
1 courgette
3 tomates
50 g d'olives vertes
2 oignons rouges
1 gaufre
Huile d'olive vierge
Aneth
Basilic

Râper les carottes et la courgette à l'aide d'une râpe. Réserver. Couper la gaufre en carrés et faire griller au four à 180 °C pendant 5 minutes. Émincer les oignons rouges, l'aneth, les olives le basilic et les tomates et mélanger dans un bol. Faire bouillir les légumes pendant 15 minutes. Passer le thon sur le gril.
Presentation : Disposer un lit avec des légumes au centre de l'assiette. Placer au-dessus la gaufre et ensuite le thon grillé. Verser la préparation à base d'oignons, de tomates et d'olives et arroser avec un filet d'huile d'olive.

2 tonijnfilets van 160 g
3 wortels
1 courgettes
3 tomaten
50 g groene olijven
2 rode uien
1 wafel
Virgine olijfolie
Venkel
Basilicum

Rasp de wortels en de courgette en zet ze apart. Bak het wafel 5 minuten op 180 °C. Hak rode uien venkel, olijven, basilicum en tomaten fijn en meng ze in een kom. Bak de groenten 15 minuten en bak ondertussen de tonijn in een grillpan.
Serveren: Schik de groenten in een cirkel in het midden van het bord. Dek het af met het wafel gevolgd door de gegrilde tonijn. Strooi de geraspte groenten erover en besprenkel met olijolie.

2 tuna filets 7 oz each
3 carrots
1 zucchini
3 tomatoes
1 3/4 oz green olives
2 red onions
1 wafer
Virgin olive oil
Fennel
Basil

Grate the carrots and the zucchini and set aside. Dice the wafer and bake it at 370 °F for 5 minutes. Chop the red onions, the fennel, the olives, the basil and the tomatoes and mix in a bowl. Boil the vegetables for 15 minutes. Cook the tuna on the grill.
To serve: Make a bed with the vegetables in the center of the plate. Put the wafer on it followed by the grilled tuna. Pour the grated vegetables on top and drizzle olive oil over it.

2 Tunfischfilet (je 160 g)
3 Möhren
1 Zucchini
3 Tomaten
50 g grüne Oliven
2 rote Zwiebeln
1 Waffel
Kaltgepresstes Olivenöl
Fenchel
Basilikum

Die Möhren und die Zucchini mit einer Reibe reiben und zur Seite stellen. Die Waffel in Quadrate schneiden und bei 180 °C im Ofen 5 Minuten grillen. Die roten Zwiebeln, den Fenchel, die Oliven, das Basilikum und die Tomaten hacken und in einer Schale vermengen. Das Gemüse 15 Minuten lang kochen. Den Tunfisch grillen.
Serviervorschlag: Das Gemüse in der Mitte des Tellers anordnen. Die Waffel und den gegrillten Tunfisch darauf legen. Das geriebene Gemüse darüber streuen und schließlich noch mit einem Schuss Olivenöl anmachen.

2 filetes de atún de 160 g
3 zanahorias
1 calabacín
3 tomates
50 g de aceitunas verdes
2 cebollas rojas
1 barquillo
Aceite de oliva virgen
Hinojo
Albahaca

Rallar las zanahorias y el calabacín con la ayuda de un rallador. Reservar. Cortar el barquillo en cuadrados y hornear a 180 °C durante 5 minutos. Picar las cebollas rojas, el hinojo, las aceitunas, la albahaca y los tomates y mezclar en un bol. Hervir las verduras durante 15 minutos. Asar el atún a la parrilla.
Emplatado: Hacer un lecho de verduras en el centro del plato. Colocar encima el barquillo y a continuación el atún asado. Verter la salsa vegetal y regar con un chorrito de aceite de oliva.

Les Étangs Mellaerts

Chef: Jean-Luc Vervier

Boulevard du Souverain 275 | 1150 Brussels
Phone: +32 2 779 36 19
Subway: Hermann-Debroux
Opening hours: Tue–Thu from noon to 2:30 pm, and from 7 pm to 10:30 pm,
weekend from noon to 11 pm, tea room from 2:30 pm to 6 pm
Average price: € 25–30
Cuisine: French and Belgian
Special features: Terrace and garden with views of the lake

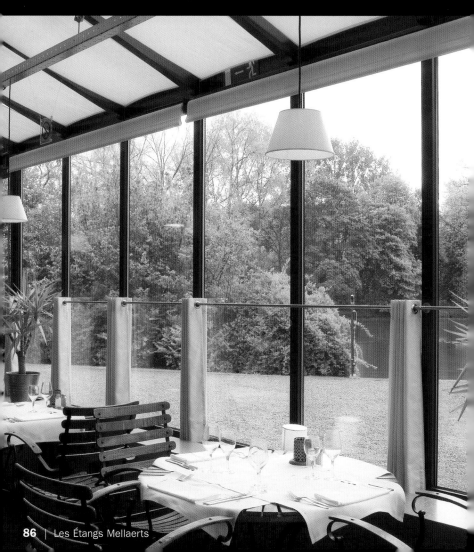

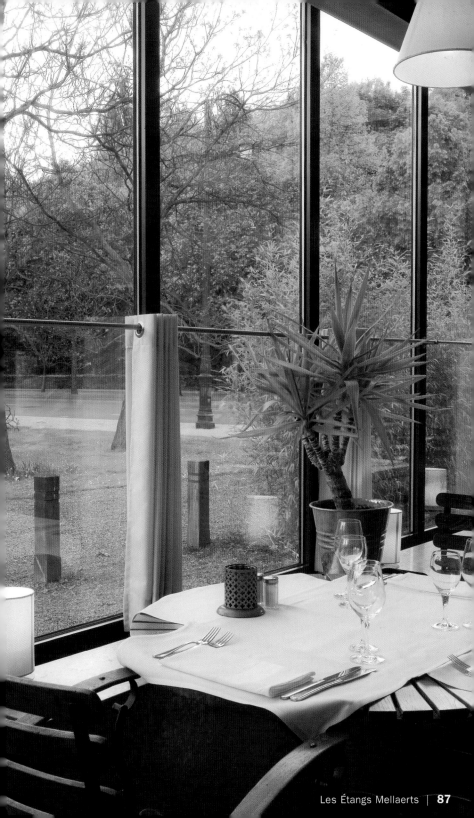

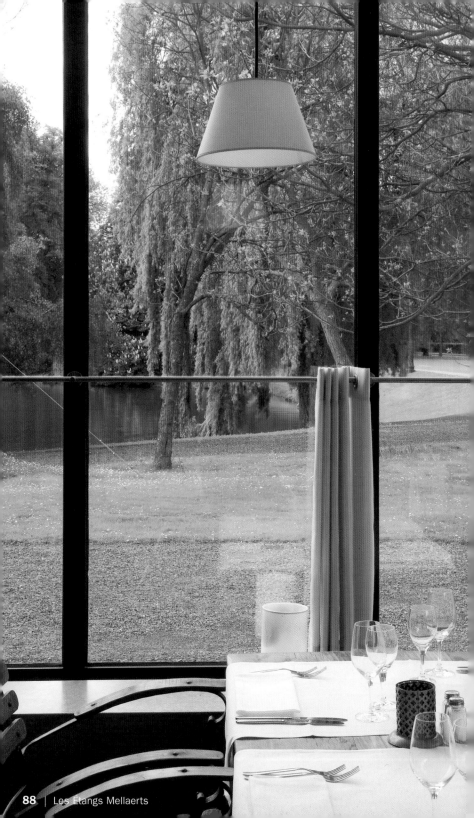

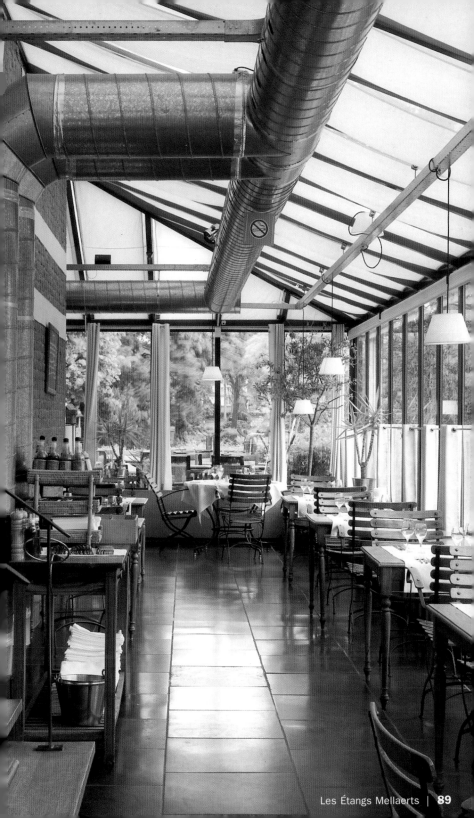

Saumon fumé
avec sauce béchamel

Gerookte Zalm met bechamelsaus
Smoked Salmon with Bechamel Sauce
Geräucherter Lachs mit Béchamelsauce
Salmón ahumado con salsa bechamel

125 g de saumon fumé
20 g de cresson d'eau
50 g de beurre
50 g de farine
500 ml de lait
50 g de fromage frais
Sel
Poivre
Noix de muscade

Pour préparer la béchamel, faire fondre la beurre et ajouter la farine, le fromage frais et, peu à peu, le lait. Remuer constamment jusqu'à obtention d'une sauce plus ou moins épaisse. As saisonner et ajouter une pincée de noix de muscade.
Presentation : Disposer la sauce sur une assiette et ajouter au-dessus le saumon fumé er cercle. Disposer les feuilles de cresson sur le saumon.

125 g gerookte zalm
20 g waterkers
50 g boter
50 g bloem
500 ml melk
50 g roomkaas
Zout
Peper
Nootmuskaat

Laat voor de bechamelsaus de boter smelten er voeg bloem, roomkaas en melk beetje bij beetje toe. Blijf voortdurend roeren tot de saus dikker wordt. Voeg zout en peper toe en een snufje gemalen nootmuskaat.
Serveren: Schenk de saus op een bord en leg de gerookte zalm er in een cirkel op. Leg de water kers op de zalm.

4 1/2 oz smoked salmon
2/3 oz watercress
1 3/4 oz butter
1 3/4 oz flour
500 ml milk
1 3/4 oz fresh cheese
Salt
Pepper
Ground nutmeg

To prepare the béchamel, melt the butter and add the flour, the fresh cheese, and the milk a little at a time. Stir constantly until the sauce is more or less thick. Add salt and pepper and a pinch of ground nutmeg.
To serve: Put the sauce on a plate and arrange the smoked salmon on it in a circular shape. Place the watercress on the salmon.

125 g geräucherter Lachs
20 g Brunnenkresse
50 g Butter
50 g Mehl
500 ml Milch
50 g Frischkäse
Salz
Pfeffer
Muskat

Zur Zubereitung der Béchamelsauce Butter schmelzen lassen und das Mehl, den Frischkäse und nach und nach die Milch hinzugeben. Ständig umrühren, bis eine einigermaßen dicke Sauce erreicht wird. Salzen, pfeffern und eine Prise Muskat hinzugeben.
Serviervorschlag: Die Sauce auf einen Teller geben und darauf den geräucherten Lachs kreisförmig anordnen. Die Brunnenkresse auf den Lachs streuen.

125 g de salmón ahumado
50 g de mantequilla
50 g de harina
500 ml de leche
50 g de queso fresco
20 g de berros
Sal
Pimienta
Nuez moscada

Para preparar la bechamel fundir la mantequilla en una sartén y agregar la harina, el queso fresco y, poco a poco, la leche. Remover constantemente hasta obtener una salsa más o menos densa. Salpimentar y añadir una pizca de nuez moscada.
Emplatado: Disponer la salsa en un plato y montar encima el salmón ahumado en forma circular. Colocar los berros sobre el salmón.

Loui

Chef: Enrico Rodati

Avenue Louise 77 | 1050 Brussels
Phone: +32 2 542 47 77
www.loui.be
Subway: Louise
Opening hours: Tue–Fri from noon to 2:30 pm, and from 7:30 pm to 10:30 pm, Sat–
from 7:30 pm to 10:30 pm (restaurant), everyday from 7 am to 1 am (lounge and ba
Average price: € 35–40
Cuisine: Mediterranean with an Oriental touch
Special features: Bar-lounge where you can taste tapas and "mezze", live jazz two
Thursdays a month

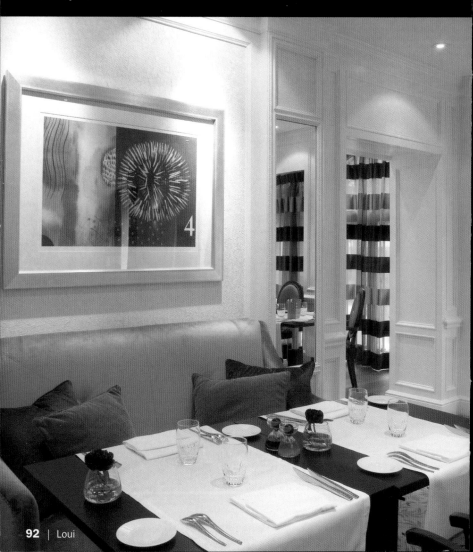

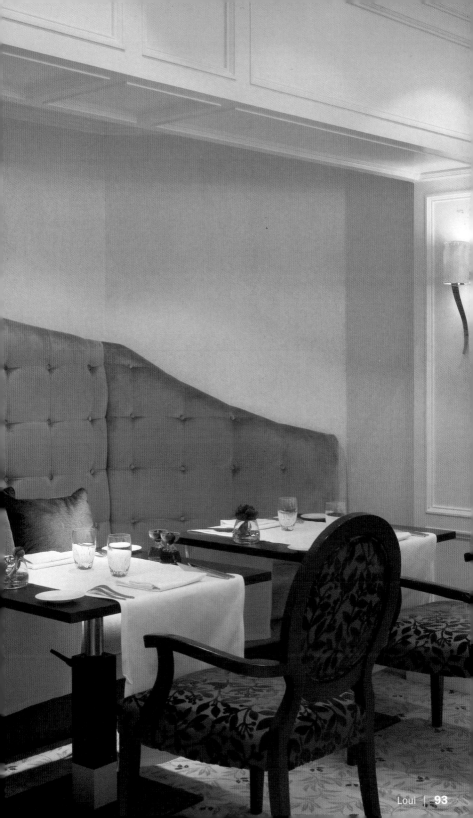

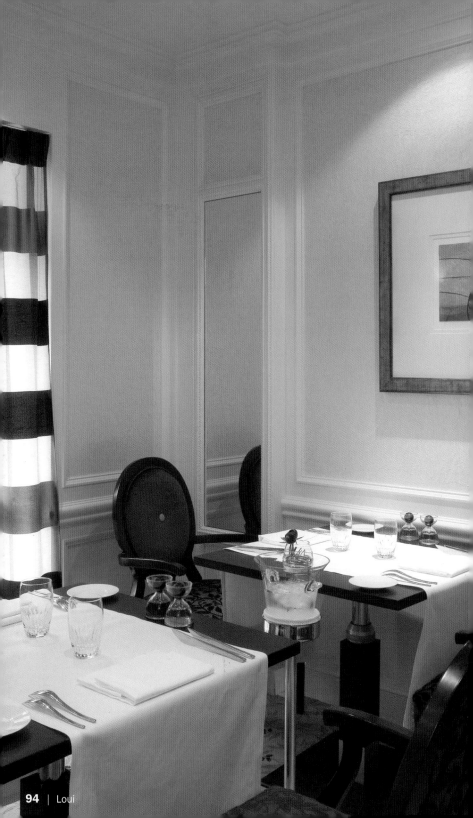

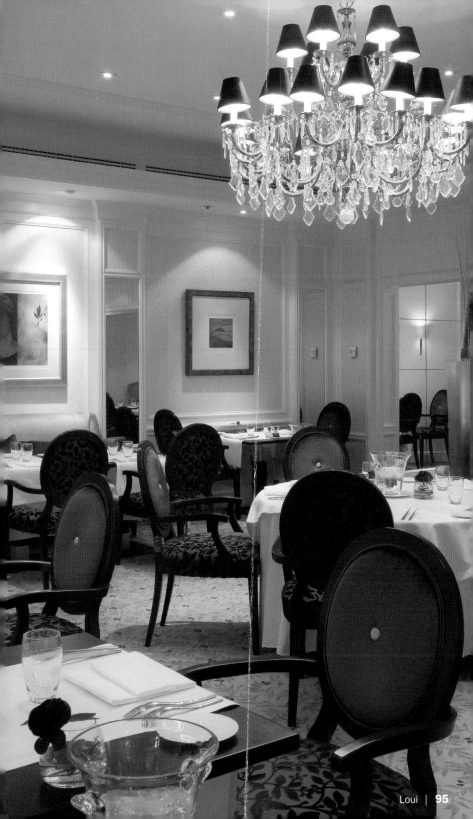

Mamy Louise

Design: Nadine Gillet | Chef: Sauvage Quentin

Rue Jean Stas 12 | 1060 Brussels
Phone: +32 2 534 25 02
www.mamylouise.be
Subway: Louise
Opening hours: Mon–Sat from 10 am to 6:30 pm
Average price: € 25
Cuisine: Belgian
Special features: Terrace, classical Belgian cuisine and delicious salades

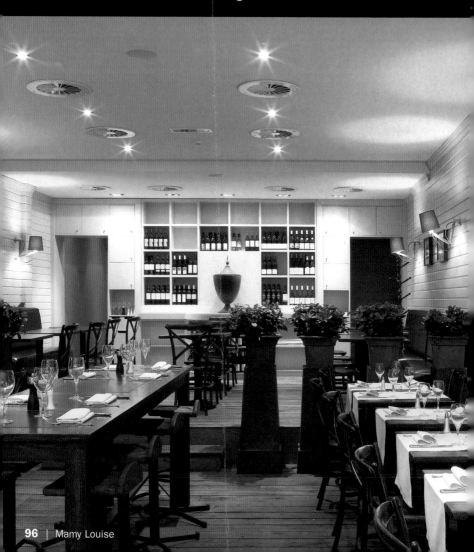

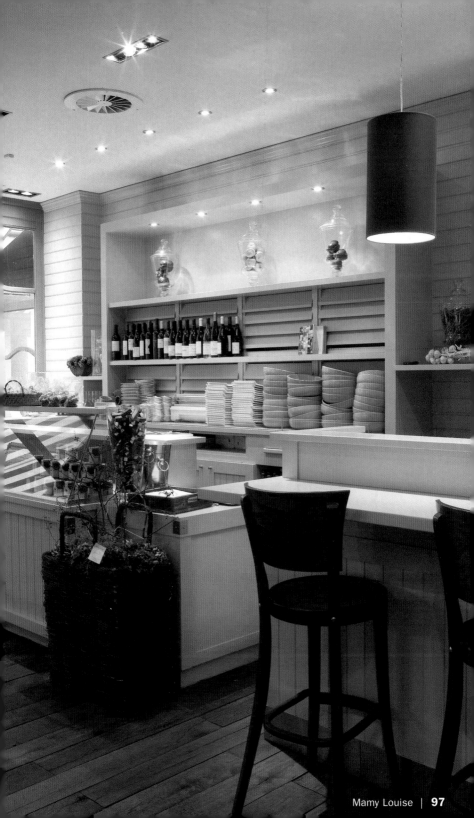

Blanquette
de veau à l'ancienne

'Blanquette de veau à l'ancienne'
"Blanquette" of Veal the Old Way
Kalbsblanquette nach traditioneller Art
"Blanquette" de ternera a la antigua

1,2 kg de veau
2 oignons
3 clous de girofle
1 brin de thym
3 feuilles de laurier
2 carottes
1 brin d'aneth
1 poireau
150 g de bacon fumé coupé très fin
150 g de beurre
50 g de farine
250 ml de purée de chou-fleur
Le jus d'1 citron
15 g de gros sel
2 g de poivre
500 ml bouillon de poule de basse-cour
500 g de champignons

Chauffer 2 l d'eau dans une grande casserole et ajouter le bouillon de poule, le sel, le poivre, le laurier, l'oignon émincé et le clou de girofle. plonger les morceaux de viande et blanchir pendant 6 minutes et réserver. Verser 100 g de beurre dans une casserole et ajouter les carottes, le poireau et le céleri coupés en julienne, le bacon et 1 oignon émincé avec une pincée de sel. Cuire à feu doux pendant 10 minutes. Faire fondre 50 g de beurre et ajouter la farine. Cuire pendant 3 minutes. Verser le bouillon et mélanger au fouet jusqu'à obtention d'une sauce huileuse. Dès qu'elle est prête, verser dans la poêle de cuisson des légumes. Ajouter la viande, la purée de chou-fleur, le jus de citron et remuer. Cuire à feux doux pendant 45 minutes. Faire revenir les champignons très finement coupés dans le beurre avec une pincée de sel et ajouter au reste des ingrédients. Cuire à nouveau pendant 20 minutes.
Presentation : Disposer la blanquette au centre de l'assiette et arroser de sauce.

1,2 kg kalfsvlees
2 uien
3 kruidnagels
1 takje tijm
3 laurierbladeren
2 wortels
1 stengel selderij
1 prei
150 g gerookt spek in dunne plakjes
150 g boter
50 g bloem
250 ml gepureerde bloemkool
Sap van 1 citroen
15 g zeezout
2 g peper
500 ml kippenbouillon
500 g champignons

Verhit 2 l water in een pan en kippenbouillon, zout, peper, laurierblad, gehakte ui en kruidnagelen toe. Voeg de stukjes kalfsvlees toe en pocheer ze 6 minuten. Schep het vlees uit de pan en zet apart. Laat 100 g boter smelten in een pan en voeg de in reepjes gesneden wortelen, prei en selderij, de bacon en een gehakte ui toe met een snuifje zout. Bak op laag vuur gedurende 10 minuten. 50 g boter smelten en het bloem toe. Bak dit 3 minuten. Voeg daarna de bouillon toe en klop de saus glad met een garde. Schenk de saus vervolgens bij de groente, voeg het kalfsvlees toe, de gepureerde bloemkool, het sap van een citroen en roer door. Laat op een laag vuur 45 minuten sudderen. Fruit de fijngehakte champignons in boter met een snufje zout en voeg ze toe aan de overige ingrediënten. Laat nog 20 minuten sudderen.
Serveren: Schep de 'Blanquette' op het midden van het bord en schenk de saus erover.

2 1/2 lb veal
2 onions
3 cloves
1 sprig of thyme
3 bay leaves
2 carrots
1 stick of celery
1 leek
5 oz finely sliced smoked bacon
5 oz butter
1 3/4 oz flour
250 ml mashed cauliflower
Juice of 1 lemon
1/2 oz coarse salt
A pinch of black pepper
500 ml free-range chicken broth
16 oz mushrooms

Heat 2 l water in a pot and add the chicken broth, the salt, the pepper, the bay leaf, 1 chopped onion, and the cloves. Submerge the pieces of veal for 6 minutes and put aside. Put 3 1/2 oz butter in a pan add add the carrots, the leek, the celery cut in julienne, the bacon, and a chopped onion with a pinch of salt. Cook over a low heat for 10 minutes. Melt 1/2 oz of butter and the flour. Cook for 3 minutes. Add the broth and use a mixer to make the sauce smooth. When it is ready pour it into the saucepan with the cooked vegetables. Add the veal, the mashed cauliflower, the juice of 1 lemon, and stir. Cook over a low heat for 45 minutes. Sauté the finely chopped mushrooms in butter with a pinch of salt and add to the rest of the ingredients. Cook for another 20 minutes. To serve: Put the "blanquette" in the center of the plate and drizzle with the sauce.

1,2 kg Kalbfleisch
2 Zwiebeln
3 Nelken
1 Zweig Thymian
3 Lorbeerblätter
2 Möhren
1 Stange Sellerie
1 Stange Lauch
150 geräucherter Speck in feinen Streifen
150 g Butter
50 g Mehl
250 ml pürierter Blumenkohl
Saft einer Zitrone
15 g grobes Salz
2 g Pfeffer
500 ml Geflügelbrühe
500 g Champignons

2 l Wasser in einem Topf erhitzen und Geflügelbrühe, Salz, Pfeffer, Lorbeer, 1 gehackte Zwiebel und die Nelken hinzufügen. Das geschnittene Fleisch 6 Minuten darin dünsten, herausnehmen und zur Seite stellen. 100 g Butter in einen Topf geben, Möhren, Lauch, Selleriestreifen, Speckstücke, 1 gehackte Zwiebel und eine Prise Salz hinzugeben. 10 Minuten lang bei niedriger Hitze dünsten. 50 g Butter schmelzen, das Mehl hinzufügen und 3 Minuten erhitzen. Die Brühe dazugeben und im Mixer mischen, bis eine glatte Sauce entsteht. Die Sauce in die Pfanne geben, in der das Gemüse gekocht wurde. Das Fleisch, den pürierten Blumenkohl und den Zitronensaft hinzugeben und rühren. 45 Minuten lang bei niedriger Hitze kochen. Die fein geschnittenen Champignons in Butter mit einer Prise Salz andünsten und zu den übrigen Zutaten geben. 20 Minuten lang weiterkochen lassen.
Serviervorschlag: Die Blanquette in der Mitte des Tellers anordnen und mit Sauce beträufeln.

1,2 kg de ternera
2 cebollas
3 clavos
1 ramita de tomillo
3 hojas de laurel
2 zanahorias
1 rama de apio
1 puerro
150 g de bacón ahumado cortado fino
150 g de mantequilla
50 g de harina
250 ml de puré de coliflor
zumo de 1 limón
15 g de sal gruesa
2 g de pimienta
500 ml de ave de corral
500 g de champiñones

Calentar 2 l de agua en una olla y añadir el caldo de ave, la sal, la pimienta, el laurel, 1 cebolla picada y el clavo. Sumergir la carne troceada durante 6 minutos y reservar. Verter 100 g de mantequilla en una cacerola y agregar las zanahorias, el puerro, el apio cortados en juliana, el bacón y 1 cebolla picada con una pizca de sal. Cocer a fuego lento durante 10 minutos. Fundir 50 g de mantequilla y agregar la harina. Cocer durante 3 minutos. Verter el caldo y mezclar con una batidora hasta obtener una salsa aceitosa. Cuando esté lista, verter en la sartén en la que se han cocido las verduras. Añadir la carne, el puré de coliflor, el jugo de limón y remover. Cocer a fuego lento durante 45 minutos. Saltear los champiñones cortados muy finos en la mantequilla con una pizca de sal y añadirlos al resto de los ingredientes. Cocer de nuevo durante 20 minutos.
Emplatado: Disponer la "blanquette" en el centro del plato y regar con la salsa.

Marolle's/Urban Cafe

Design: Anthony Schorr | Chef: Anthony Polakowski

Rue Haute 179 | 1000 Brussels
Phone: +32 2 513 13 40
Subway: Louise/Porte de Hal
Opening hours: Tue–Sat from noon to 3 pm, and from 6 pm to midnight
Average price: € 15
Cuisine: International-fusion
Special features: Catering and delivery to companies during lunch time

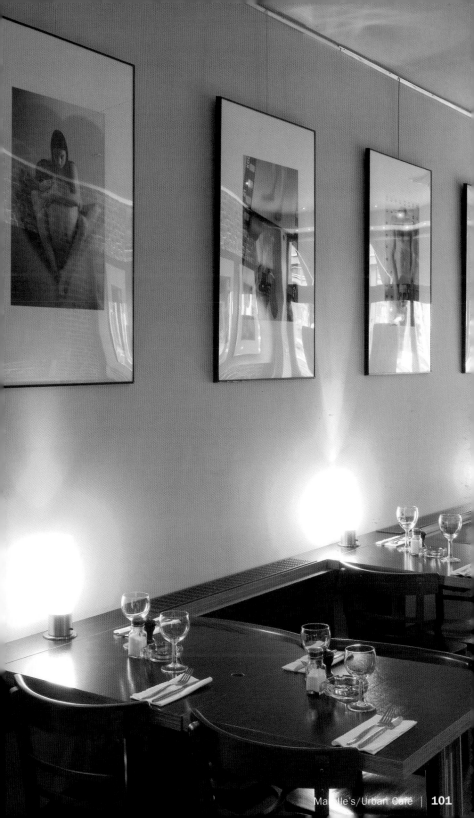

Vermicelles

au poulet et légumes sautés au wok

Noedels met roergebakken kip en groenten

Noodles with Stir Fried Chicken and Vegetables

Nudeln mit Hähnchen und Gemüse im Wok gedünstet

Fideos con pollo y verduras salteadas al wok

200 g de vermicelles
100 ml de bouillon de poule
1/2 oignon coupé en grosses lamelles
1 gousse d'ail coupée en très fines lamelles
15 g de gingembre frais
15 g de sambal oelek
50 g de pousses de soja
30 ml d'huile végétale
1 carotte coupée en lanières
30 ml de sauce de soja
15 ml d'alcool de riz
150 g de poulet coupé en lanières
1 échalote grossièrement émincée
2 champignons grossièrement émincés
12 pousses de bambou égouttées
1/3 de piment doux rouge coupé grossièrement

1/2 courgette coupée en tranches
1/2 de limette
Thym

Chauffer un wok à feu modéré jusqu'à ce qu'il soit très chaud et ajouter l'huile végétale. Ajouter l'ail, l'échalote, le gingembre, le sambal oelek et le poulet. Remuer et faire frire pendant 5 minutes. Ajouter les légumes, remuer et frire pendant 3 minutes. Ajouter l'alcool de riz, la sauce de soja, le bouillon de poule et vérifier l'assaisonnement. Ajouter les vermicelles, remuer et frire pendant 1 minute.
Presentation : Diviser le contenu sur deux assiettes et décorer un quartier de limette sur chacune. Décorer d'une pincée de thym.

200 g noedels
100 ml kippenbouillon
1/2 ui in dikke plakken
1 teen knoflook in dunne plakjes gesneden
15 g vers gember
15 g sambal oelek
50 g taugé
30 ml plantaardige olie
1 worteltje in reepjes gesneden
30 ml sojasaus
15 ml rijstwijn
150 g kip in reepjes
1 sjalotje grof gehakt
2 grote champignons in dikke plakken
12 stukjes gedroogde bamboescheut
1/3 rode paprika in dikke repen

1/2 courgette in plakjes
1/2 limoen
Tijm

Verhit de wok gedurende tot hij gloeiend heet is en voeg dan de olie toe. Doe knoflook, sjalotje, gember, sambal oelek en kip in de pan en roerbak gedurende 5 minuten. Voeg de groenten toe en roerbak deze nog 3 minuten. Schenk de rijstwijn en de kippenbouillon erbij en breng op smaak. Voeg de noedels toe en schep ze door de groenten, bak ze nog 1 minuut mee.
Serveren: Serveer op twee borden en knijp boven elk bord een stukje limoen uit. Garneer met een takje tijm.

7 oz noodles
100 ml chicken broth
1/2 onion cut in thick slices
1 clove garlic sliced very thin
1/2 oz fresh ginger
1/2 oz sambal oelek
50 g bean sprouts
30 ml vegetable oil
1 carrot cut in strips
30 ml soy sauce
15 ml rice wine
5 oz chicken cut into strips
1 shallot rough chopped
2 mushrooms cut in thick slices
12 dried bamboo sprouts
1/3 sweet red pepper cut into thick strips

1/2 zucchini sliced
1/2 lime
Thyme

Heat the wok on medium until it is very hot and add vegetable oil. Add the garlic, shallot, ginger, the sambal oelek, and the chicken. Toss and cook for 5 minutes. Add the vegetables, toss and cook for 3 minutes. Add the rice wine, the soy sauce, the chicken broth, and taste. Add the noodles and toss and cook them for 1 minute. To serve: Serve on two plates and squeeze a wedge of lime over each one. Garnish with a small piece of thyme.

200 g Nudeln
100 ml Hühnerbrühe
1/2 Zwiebel, in dicke Scheiben geschnitten
1 Knoblauchzehe, in feine Scheiben geschnitten
15 g frischen Ingwer
15 g Sambal Oelek
50 g Sojasprossen
30 ml Pflanzenöl
1 Möhre, in Streifen geschnitten
30 ml Sojasauce
15 ml Reiswein
150 g Hähnchenfleisch, in Streifen
1 Schalotte, grob gehackt
2 Champignons, in dicke Scheiben geschnitten
12 getrocknete Bambussprossen
1/3 roter Paprika, in breite Streifen geschnitten

1/2 Zucchini, in Scheiben geschnitten
1/2 Limette
Thymian

Den Wok auf mittlerer Temperatur erhitzen, dann das Pflanzenöl hineingeben. Den Knoblauch, die Schalotte, den Ingwer, das Sambal Oelek und das Hähnchenfleisch hinzugeben. Unter Rühren 5 Minuten scharf anbraten. Das Gemüse hinzugeben und 3 Minuten anbraten. Den Reiswein, die Sojasauce und die Gemüsebrühe hinzugeben und abschmecken. Die Nudeln hinzugeben und 1 Minuten anbraten.
Serviervorschlag: Den Inhalt auf zwei Teller verteilen und jeweils ein Viertel der Limette über jedem Teller ausdrücken. Mit etwas Thymian dekorieren.

200 g de fideos
100 ml de caldo de pollo
1/2 cebolla cortada en láminas gruesas
1 diente de ajo cortado en láminas muy finas
15 g de jengibre fresco
15 g de sambal oelek
50 g de brotes de soja
30 ml de aceite vegetal
1 zanahoria cortada en tiras
30 ml de salsa de soja
15 ml de vino de arroz
150 g de pollo cortado en tiras
1 chalote cortado grueso
2 champiñones cortados en láminas gruesas
12 brotes de bambú desecados
1/3 de pimiento dulce rojo cortado grueso

1/2 de calabacín cortado en láminas
1/2 de lima
Tomillo

Calentar un wok a fuego medio hasta que esté muy caliente y añadir el aceite vegetal. Agregar el ajo, el chalote, el jengibre, el sambal oelek y el pollo. Remover y freír durante 5 minutos. Añadir las verduras, remover y freír durante 3 minutos más. Agregar el vino de arroz, la salsa de soja, el caldo de pollo y comprobar el aderezo. Añadir los fideos, remover y freír durante 1 minuto.
Emplatado: Dividir el contenido en dos platos y esparcir un cuarto de lima sobre cada uno. Decorar con una pizca de tomillo.

Re-Source

Design: Sarah Alewaters, Christian Baby Yumbi | Chef: Christian Baby Yumbi

Rue du Midi 164 | 1000 Brussels
Phone: +32 2 514 32 23
www.restaurantresource.be
Subway: Anneessens
Opening hours: Tue–Sat from noon to 2:30 pm, from 7 pm to 10 pm
Average price: Business lunch € 15, Menu Re-source 5 services € 38, Menu Slow 8 services € 53
Cuisine: Creative French cuisine
Special features: Contemporary works of art by Alexandre Dumont on the walls

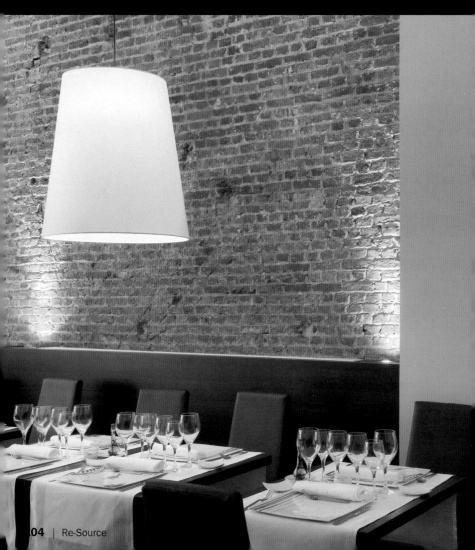

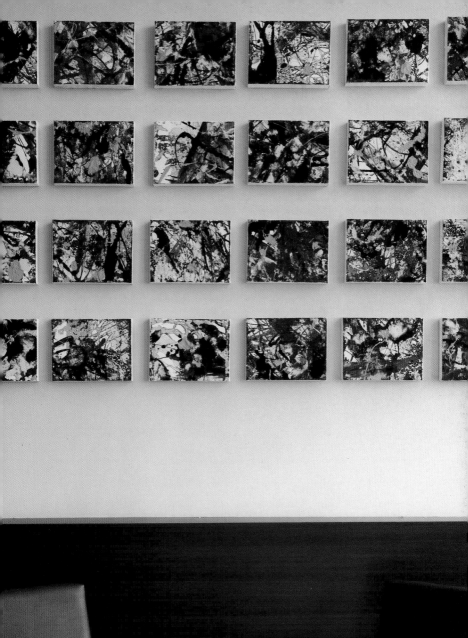
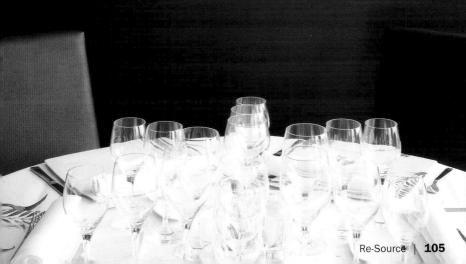

Dégustation

de légumes

Groenteassortiment
Vegetable Tasting
Gemüseplatte
Degustación de vegetales

Mousse de racines de persil :
200 g de racines de persil
100 g de agar-agar
35 g de beurre
1/2 citron
100 ml de bouillon de légumes
1 échalote
Blanchir les racines de persil dans le bouillon et les émincer. Faire fondre le beurre et faire cuire les échalotes jusqu'à ce qu'elles rendent leur eau. Ajouter les racines de persil et le jus d'un demi citron, verser dans le bouillon, ajouter l'agar-agar et remuer. Battre la crème et mélanger les deux éléments.

Gâteau de Vitelotte :
500 g de pommes de terre « vitelotte »

1 gousse d'ail
1 petite échalote
400 ml de bouillon de poule
100 ml de crème fraîche
1 g d'agar-agar
Noix de muscade
Huile d'olive vierge extra
Sel et poivre
Faire revenir l'échalote sans la faire colorer dans un peu d'huile d'olive. Ajouter l'ail et les pommes de terre « vitelotte » propres, éplu-chées et coupées en gros dés. Mouiller avec le bouillon de volaille et l'agar-agar. Remuer et faire réduire pendant 10 minutes. Assaisonner et remuer une dernière fois. Verser dans un moule d'une hauteur de 1,5 cm environ. Réserver au frais et couper en carrés.

Mousse van peterseliewortel:
200 g peterseliewortel
100 g agar agar (vegetarische gelatine)
35 g boter
1/2 citroen
100 ml groentebouillon
1 sjalotje
Blancheer de peterseliewortel in de bouillon en dep ze droog. Laat de boter smelten en fruit de sjalotjes tot ze vocht afgeven. Voeg de peterse-liewortel en het sap van een halve citroen toe, schenk de bouillon erbij en de agar agar. Meng het geheel goed door.

'Vitelotte' pudding:
500 g 'vitelotte' aardappelen

1 teen knoflook
1 sjalotje
400 ml kippenbouillon
100 ml crème fraîche
1 g agar agar
Gemalen nootmuskaat
Extra virgine olijfolie
Zout en peper
Fruit het sjalotje in wat olijfolie. Voeg de knoflook en de schoongemaakte, geschilde en in grote blokjes gesneden 'vitelotte' aardappelen toe. Schenk de bouillon en de agar agar erbij. Roer door en laat tien minuten inkoken. Breng op smaak en roer nog een keer door. Giet de aardappelen in een schaal van ongeveer 1,5 cm diep. Laat op een koele plek opstijven en snij de pudding in vierkantjes.

Parsley Root Mousse:
7 oz of parsley root
3 1/2 oz of agar agar
1 1/4 oz of butter
1/2 lemon
100 ml of vegetable broth
1 shallot
Blanch the parsley roots in the broth and dry them. Melt the butter cook the shallots until they begin to render their own liquid. Add the parsley roots and the juice of 1/2 lemon, steep in the broth, add the agar agar and stir. Stir to mix the elements well.

"Vitellote" Pudding:
1 lb 1 1/2 oz of "vitellote" potatoes

1 garlic stalk
1 small shallot
400 ml chicken broth
100 ml crème fraîche
1 g of agar agar
Ground nutmeg
Extra virgin olive oil
Salt and pepper
Sauté the white shallot in a small amount of olive oil. Add the garlic and the cleaned "vitellote" potatoes, peeled and cut in large dices. Soak in the chicken broth and the agar agar. Stir and reduce for 10 minutes. Season and stir one last time. Pour into a tray approximately 1/2 inch deep. Keep in a cool place and cut into squares.

Petersilienwurzelmousse:
200 g Petersilienwurzeln
100 g Agar-Agar
35 g Butter
1/2 Zitrone
100 ml Gemüsebrühe
1 Schalotte
Die Petersilienwurzeln in der Gemüsebrühe blanchieren, dann abgießen und die Brühe beiseite stellen. Die Butter schmelzen und die Schalotten andünsten. Die Petersilienwurzeln und den Saft einer halben Zitrone hinzugeben, die Brühe hineingießen, Agar-Agar hinzugeben und rühren. Die Mousse schlagen, damit sich die Zutaten gut vermischen.

Vitelottepastete:
500 g Kartoffel „Vitelotte"

1 Knoblauchzehe
1 kleine Schalotte
400 ml Geflügelbrühe
100 ml Crème fraîche
1 g Agar-Agar
Muskatnuss
Kaltgepresstes naturreines Olivenöl
Salz und Pfeffer
Die Schalotte in Olivenöl anschmoren, jedoch nicht braun werden lassen. Den Knoblauch und die Kartoffeln geschält und in große Würfel geschnitten hinzugeben. Mit der Gemüsebrühe und dem Agar-Agar vermischen. Rühren und 10 Minuten aufkochen lassen. Salzen, pfeffern und noch einmal rühren. Auf ein ca. 1,5 cm hohes Blech geben. Kühl aufbewahren und in Quadrate schneiden.

Mousse de raíz de perejil:
200 g de raíces de perejil
100 g de agar agar
35 g de mantequilla
1/2 limón
100 ml de caldo de verduras
1 chalote
Blanquear las raíces de perejil dentro del caldo desecarlas. Fundir la mantequilla y cocer los chalotes hasta que empiecen a extraer su propia agua. Añadir las raíces de perejil y el zumo de medio limón, empapar en el caldo, agregar el agar agar y remover. Batir la crema y mezclar los dos elementos.

Pastel de patata:
500 g de patatas vitelotte

1 vaina de ajo
1 chalote pequeño
400 ml de caldo de ave
100 ml de crema fresca
1 g de agar agar
Nuez moscada
Aceite de oliva virgen extra
Sal y pimienta
Hervir el chalote sin coloración en un poco de aceite de oliva. Añadir el ajo y las patatas "vitelotte" limpias, peladas y cortadas en dados grandes. Empapar con el caldo de ave y el agar agar. Remover y reducir durante 10 minutos. Sazonar y remover por última vez. Verter en una bandeja a una altura de 1,5 cm aproximadamente. Guardar en fresco y recortar en cuadrados.

Rosa Art Lounge

Design: Francesco Ravo | Chef: Ouadi Nordine

Boulevard de Waterloo 36-37 | 1000 Brussels
Phone: +32 2 502 22 53
www.rosa-artlounge.com
Subway: Porte de Namur
Opening hours: Tue–Sat from 7 pm to 3:30 am
Average price: € 50
Cuisine: Comfort-food concept with influences of Asian, French and Italian cuisine
Special features: A multifunctional space where gastronomy, modern music, desig
and contemporary art meet, 80's inspired avantgarde look with ultra-modern Italia
furniture

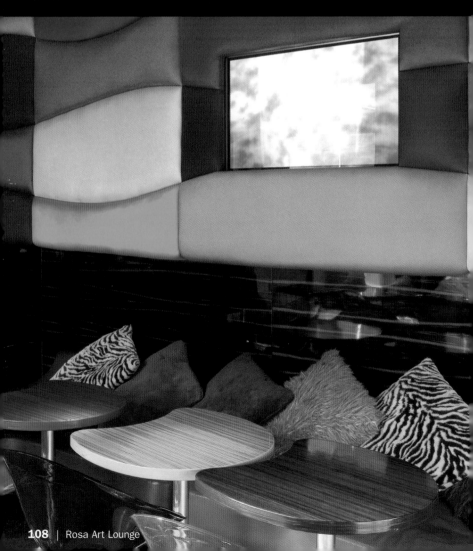

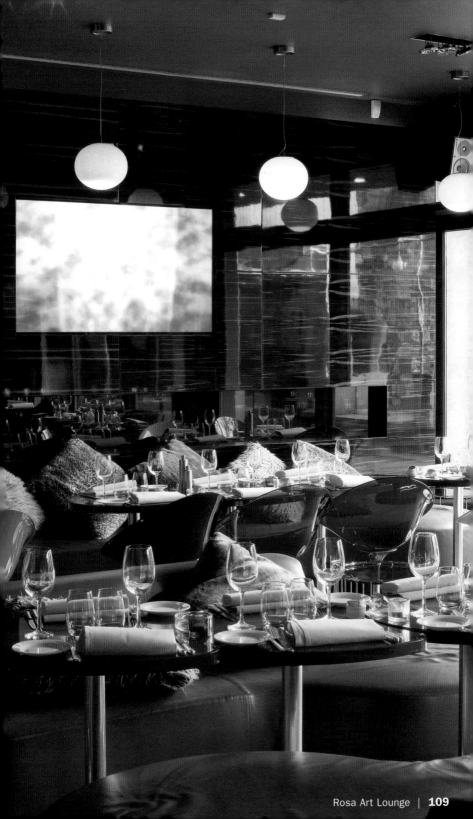

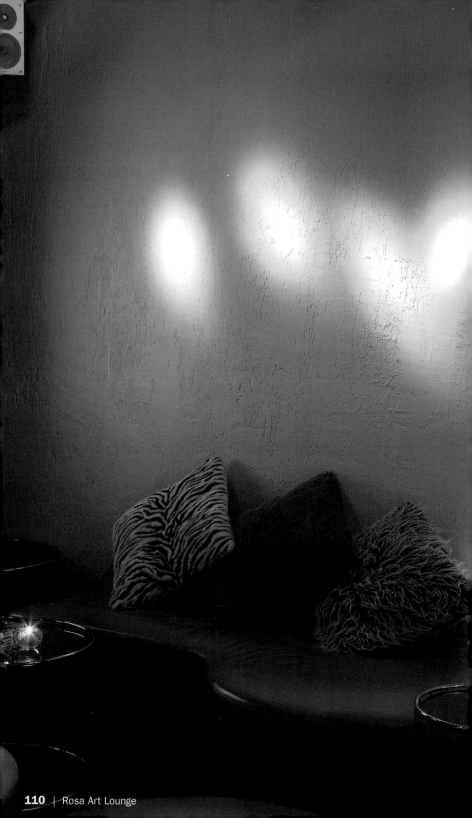

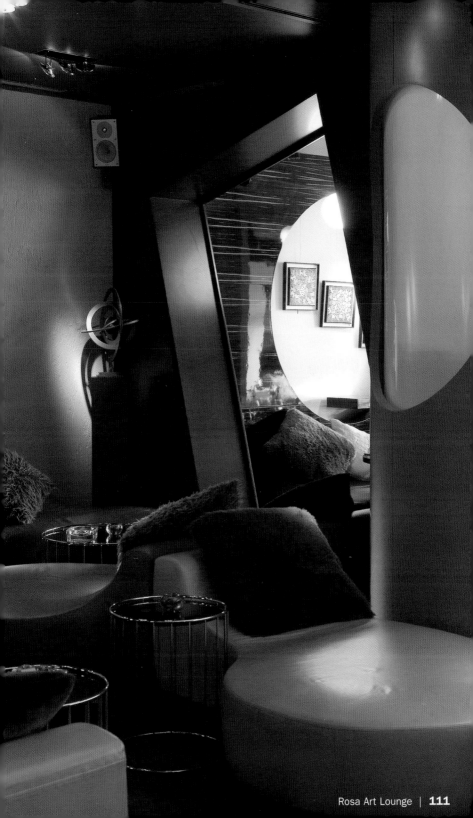

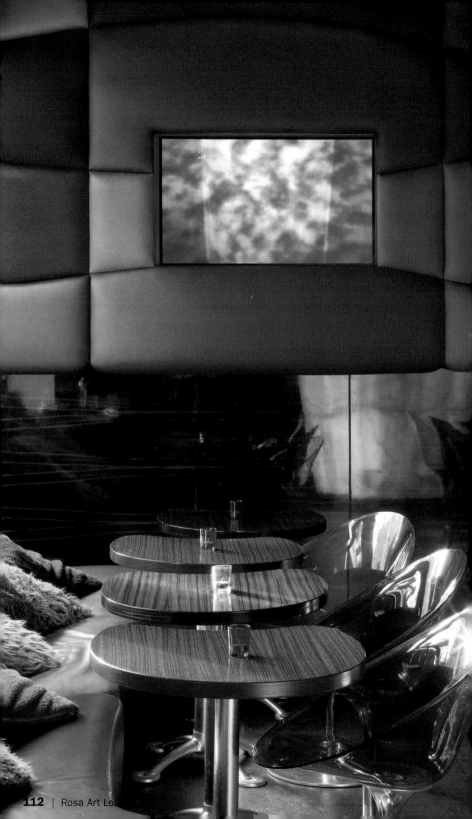

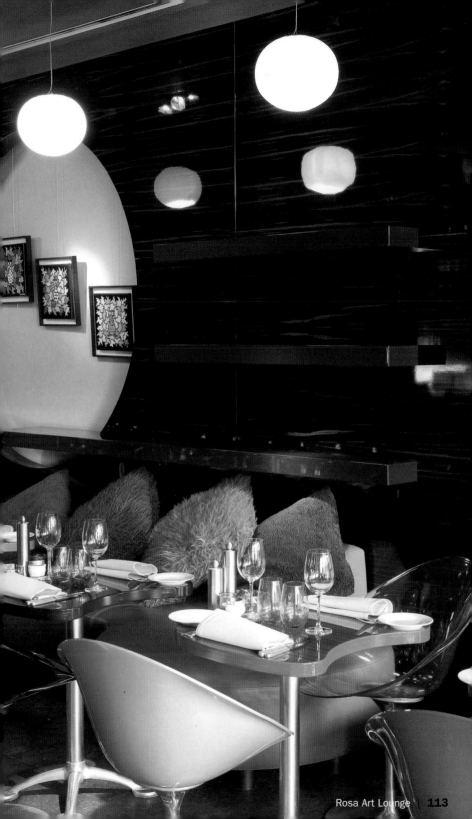

Roxi

Design: Roxane Enescu | Chef: Jean-Marc Leroy

Rue du Bailli 82 | 1050 Brussels
Phone: +32 2 646 17 92
www.roxi.be
Subway: Porte Louise
Opening hours: Mon–Sun from 8 am to 1 am
Average price: € 30
Cuisine: International
Special features: Great selection of cocktails and wines from all over the world, terrace, and livemusic

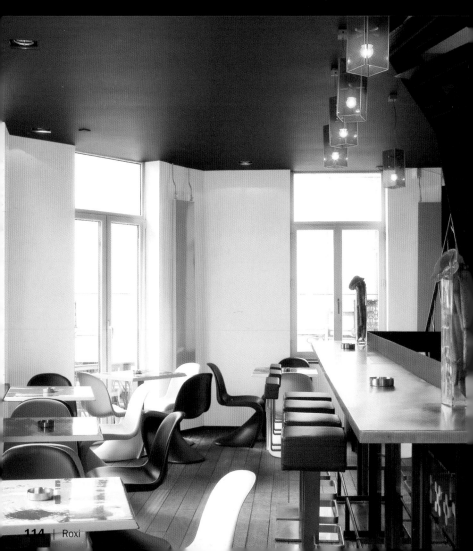

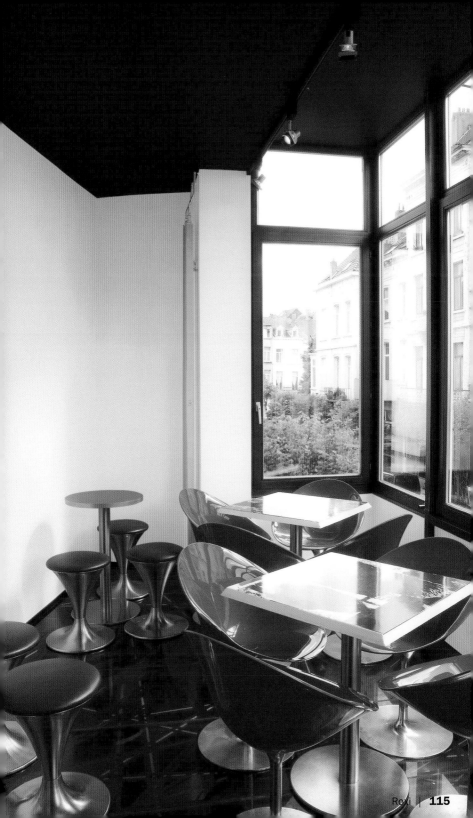

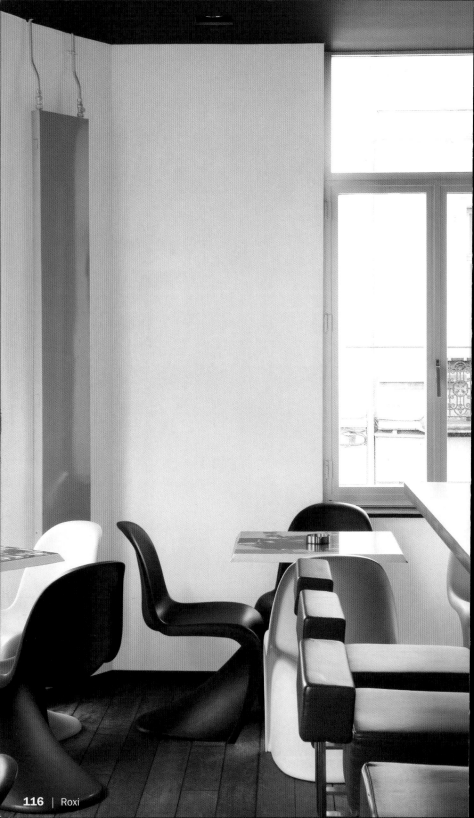

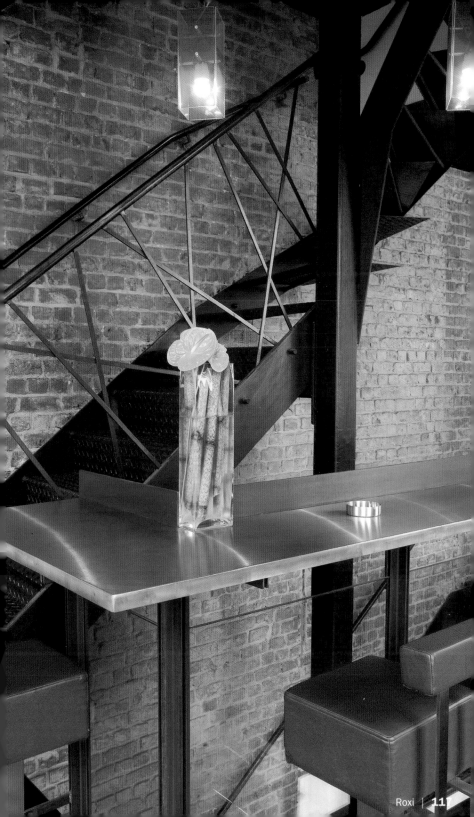

Scirocco

Design: Francesca Dantini | Chef: Massimo Mastrorilli, Niccolo Ferro

Chaussée de Vleurgat 50 | 1050 Brussels
Phone: +32 2 640 32 42
www.scirocco.be
Subway: Louise
Opening hours: Mon–Fri from noon to 2:30 pm, and Mon–Sat from 6:30 pm to 11:30 pm, Sun closed
Average price: € 15–25
Cuisine: Italian
Special features: Appetizers in an Italian style, garden, and wine bar

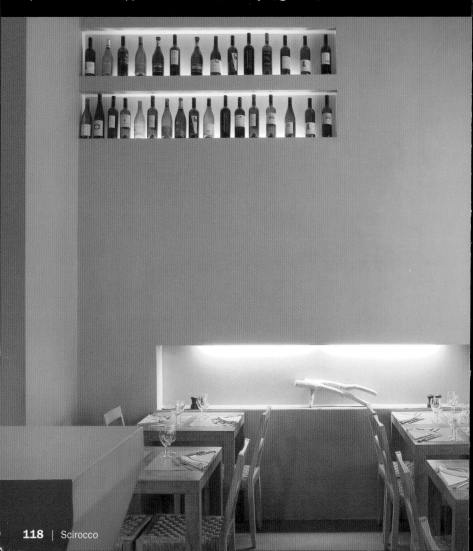

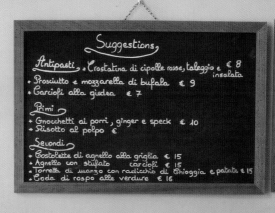

Suggestions

Antipasti
- Crostatina di cipolle rosse, taleggio e insalata € 8
- Prosciutto e mozzarella di bufala € 9
- Carciofi alla giudea € 7

Primi
- Gnocchetti ai porri, ginger e speck € 10
- Risotto al polpo €

Secondi
- Costolette di agnello alla griglia € 15
- Agnello con stufato carciofi € 15
- Torretta di manzo con radicchio di Chioggia e patate € 15
- Coda di rospo alle verdure € 16

- Pan di Spag
- Souffle al
- Crostatina
- Panna cotta
- Ananas car

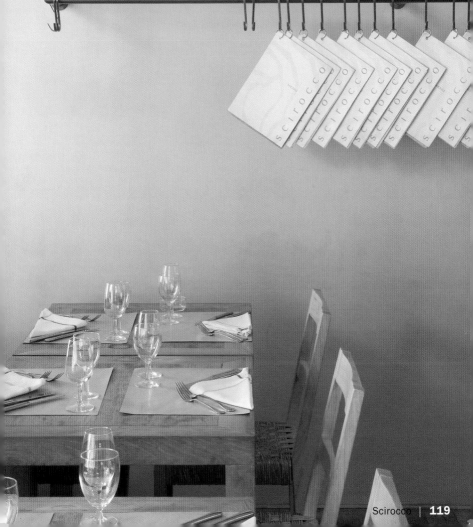

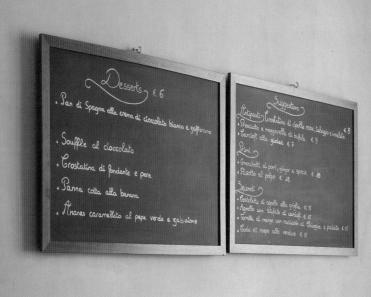

Desserts € 6

• Pan di Spagna alla crema di cioccolato bianco e zafferano

• Souffle al cioccolato

• Crostatina di fondente e pere

• Panna cotta alla banana

• Ananas caramellato al pepe verde e zabaione

Suggestions

Antipasti Crostatina di cipolle rosse, taleggio e insalata
• Prosciutto e mozzarella di bufala € 9
• Carciofi alla giudea € 7

Primi
• Gnocchetti ai porri, ginger e speck € 10
• Risotto al polpo € 11

Secondi
• Costoletta di agnello alla griglia € 15
• Agnello con sfilato di carciofi € 15
• Tortelli di mango con radicchio di Chioggia e patate € 15
• Coda di rospo alle verdure € 15

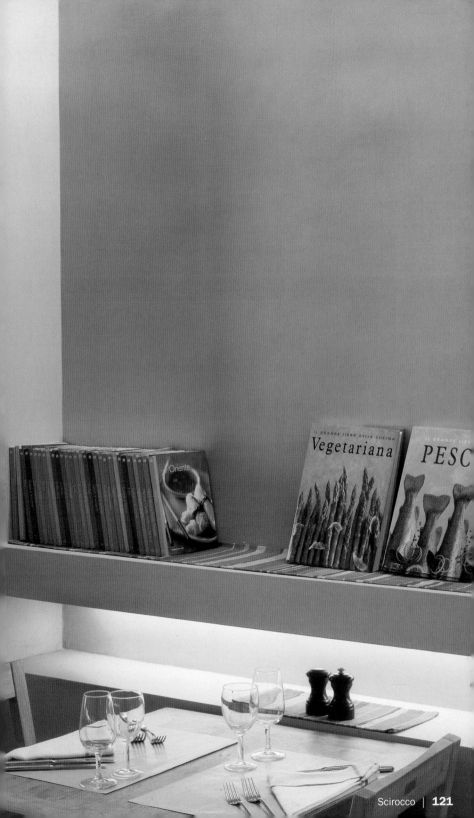

Pansotti
à la sauce de noix

Pansotti met walnotensaus
Pansotti with Walnut Sauce
Pansotti mit Walnusssauce
Pansotti con salsa de nueces

100 g de pansotti d'épinards
500 g de noix sans coques
25 g de mie de pan
30 g de ricota
20 g de parmesan râpé
20 g de graines de pignon
1 l de lait
Huile d'olive
5 g d'orégano
Ail et sel
Persil

Pour préparer la sauce, faire cuire à la vapeur les noix et leur ôter la peau; ramollir le pain avec le lait, le presser et le mettre dans un en mortier. Écraser les noix et le pain et mélanger peu à peu avec une gousse d'ail, le sel et les pignons. Obtenir une pâte homogène et ajouter le parmesan, l'orégano, la ricota et 3 c. à soupe d'huile. Placer dans un récipient et mettre au réfrigérateur. Faire bouillir la pâte dans de l'eau salée et filtrer.
Presentation : Disposer sur une assiette plate les pansotti à côté de la sauce aux noix. Saupoudrer de quelques noix de beurre et décorer de persil émincé. Servir bien chaud.

100 g pansotti
500 g gepelde walnoten
25 g brood zonder korst
30 g ricotta
20 g geraspte parmezaanse kaas
20 g pijnboompitten
1 l melk
Olijfolie
5 g oregano
Knoflook en zout
Peterselie

Stoom voor de saus de walnoten en verwijder de schilletjes. Laat het brood in de melk weken, knijp het uit en doe het in een vijzel. Wrijf de walnoten fijn met het brood en voeg geleidelijk het teentje knoflook, het zout en de pijnboompitten toe. Meng het tot een gladde puree en voeg dan parmezaanse kaas, oregano, ricotta en 3 lepels olijfolie toe. Schep de saus in een bakje en zet dit in de koelkast. Kook de pansotti in gezouten water en giet ze af.
Serveren: Schep de pansotti op een bord met de walnotensaus. Bestrooi met wat noten en decoreer met gehakte peterselie. Dien heel heet op.

3 1/2 pansotti spinach
16 oz walnut meats
3/4 oz bread with the crust removed
1 oz ricotta cheese
2/3 oz grated Parmesan cheese
2/3 oz pine nuts
1 l milk
Olive oil
5 g oregano
Garlic and salt
Parsley

To prepare the sauce, steam the walnut meat and remove the skin; soak the bread in the milk, squeeze it and put it in a mortar. Grind the walnuts with the bread and add a clove of garlic, the salt, and the pine nuts a little at a time. Make a smooth paste and add Parmesan cheese, the oregano, the ricotta, and 3 tbsp olive oil. Boil the pansotti in salted water and strain.
To serve: Place the pansotti on a platter along with the walnut sauce. Sprinkle with a few nuts and decorate with chopped parsley. Serve very hot.

100 g Spinatpansotti
500 g Walnüsse ohne Schale
25 g Brot ohne Kruste
30 g Ricotta
20 g geriebener Parmesan
20 g Pinienkerne
1 l Milch
Olivenöl
5 g Oregano
Knoblauch und Salz
Petersilie

Für die Sauce die Nüsse im Dampf kochen und die Haut entfernen. Das Brot in der Milch einweichen, ausdrücken und in einen Mixer geben. Die Nüsse und das Brot zerkleinern und langsam mit 1 Knoblauchzehe, Salz und Pinienkernen mischen, bis eine glatte Masse entsteht. Den Parmesankäse, den Oregano, den Ricotta und 3 EL Öl hinzugeben. In einer Schüssel im Kühlschrank kaltstellen. Die Pansotti in reichlich Salzwasser kochen, abseihen.
Serviervorschlag: Die Pansotti zusammen mit der Nusssauce auf einem flachen Teller anrichten. Ein paar Nüsse darüber streuen, mit gehackter Petersilie dekorieren und sehr heiß servieren.

100 g de pansotti de espinacas
500 g de nueces sin cáscara
25 g de miga de pan
30 g de ricotta
20 g de parmesano rallado
20 g de piñones
1 l de leche
Aceite de oliva
5 g de orégano
Ajo y sal
Perejil

Para preparar la salsa, hervir al vapor las nueces y quitarles la piel; remojar el pan con la leche, escurrirlo e introducirlo en un mortero. Machacar las nueces y el pan y mezclar poco a poco con un diente de ajo, los piñones y sal. Obtener una pasta homogénea y añadir el queso parmesano, el orégano, la ricotta y 3 cucharadas de aceite. Guardar en un recipiente y conservar en el frigorífico. Hervir la pasta en abundante agua salada y colar.
Emplatado: Disponer en un plato plano los pansotti y regar con la salsa. Espolvorear con algunas nueces y decorar con perejil picado. Servir bien caliente.

Switch

Design: Evan Triantopoulos | Chef: Stéphanie Thonos

Rue de Flandre 6 | 1000 Brussels
Phone: +32 2 503 14 80
www.resto.com/leswitch
Subway: Ste. Catherine
Opening hours: Tue–Sat from noon to 2:30 pm, and from 6:30 pm to 10 pm
Average price: € 28–38
Cuisine: Creative French
Special features: You can create your own personal dish from a choice of element.

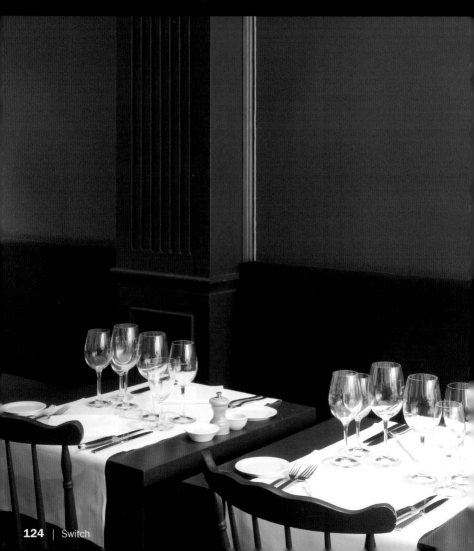

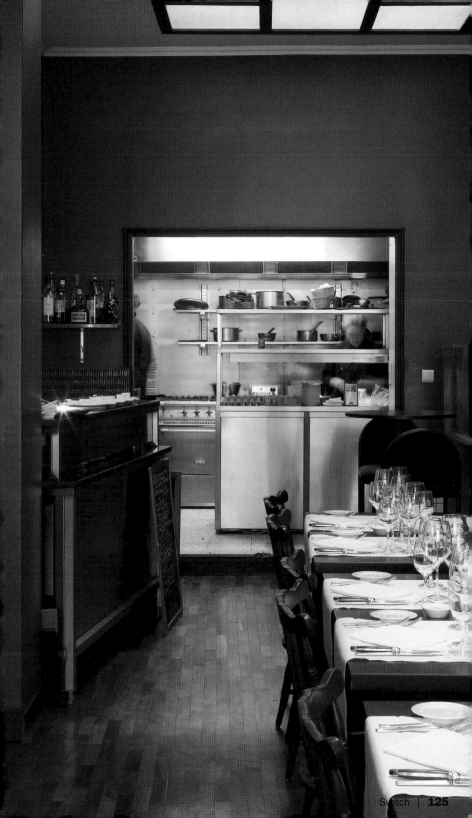

Œuf poché à la truffe

avec des asperges de Malines

Gepocheerd ei met truffels en asperges

Poached Egg with Truffles and Malines Asparagus

Pochiertes Ei mit Trüffel und Mechelner Spargel

Huevo escalfado a la trufa con espárragos de Malines

1 œuf
3 asperges de Malines
50 ml de crème
5 ml de jus de truffe
2 g de truffe
15 ml de vinaigre blanc
15 ml de bouillon de veau

Faire bouillir les asperges pendant 5 minutes. Retirer l'eau et les égoutter. Dans une poêle, réduire la crème à feu très doux jusqu'à ce qu'el-le épaississe. Ajouter le jus de truffe de et les petits morceaux de truffe. Ensuite, ajouter les asperges. Mettre à bouillir une petite casserole d'eau individuelle avec une grande cuillère de vinaigre blanc. Casser l'œuf sur un verre, le verser dans la pettie casserolle et bouillir pendant 4 minutes environ.
Service : Disposer les asperges sur une assiette et mettre l'œuf poché au-dessus. Arroser l'œuf de la crème de truffe et ajouter un peu de bouillon de veau.

1 ei
3 asperges
50 ml slagroom
5 ml truffelolie
2 g truffel
15 ml blanke azijn
15 ml kalfsbouillon

Kook de asperges in 5 minuten gaar. Schep ze uit het water en dep ze droog. Kook in een pan met dikke bodem de room op laag vuur in tot hij dikker wordt. Voeg de truffelolie en de stukjes truffel toe, gevolgd door de asperges. Breng in een pannetje water aan de kook met 1 lepel azijn. Breek het ei boven een glas en laat het in het water glijden. Pocheer het ei ongeveer 4 minuten.
Serveren: schep de asperges op een bord en leg het ei erop. Zeef de truffelcrème boven het ei en voeg er wat kalfsbouillon aan toe.

1 egg
3 Malines asparagus
50 ml cream
5 ml truffle oil
A pinch of truffle
15 ml white vinegar
15 ml veal broth

Boil the asparagus for 5 minutes. Remove from the water and pat dry. In a frying pan reduce the cream on a very low heat until it thickens. Add the truffle oil and pieces of truffle. Then add the asparagus. Boil some water with 1 tbsp of white vinegar in a small pot. Crack the egg into a glass, pour it into the water and poach for approximately 4 minutes.

To serve: Put the asparagus on a plate and place the poached egg on top. Strain the truffle cream over the egg and add a small amount of veal broth.

1 Ei
3 Stangen Mechelner Spargel
50 ml Sahne
5 ml Trüffelsaft
2 g Trüffel
15 ml weißer Essig
15 ml Kalbsbrühe

Den Spargel 5 Minuten kochen, aus dem Wasser nehmen. Die Sahne in einer Pfanne auf sehr niedriger Flamme aufkochen, bis sie dick wird. Den Trüffelsaft und die Trüffelstücke hinzugeben. Anschließend den Spargel hineinlegen. In einem kleinen Topf Wasser mit 1 EL weißem Essig zum Kochen bringen. Das Ei in ein Glas schlagen, in den Topf gießen und ungefähr 4 Minuten lang kochen.

Serviervorschlag: Den Spargel auf einen Teller geben und das pochierte Ei darüber legen. Die Trüffelcreme über dem Ei abseihen und etwas Kalbsbrühe hinzufügen.

1 huevo
3 espárragos de Malines
50 ml de nata
5 ml de jugo de trufa
2 g de trufa
15 ml de vinagre blanco
15 ml de caldo de ternera

Hervir los espárragos durante 5 minutos. Escurrir el agua y secarlos. En una sartén, reducir la nata a fuego muy bajo hasta que se espese. Añadir el jugo y la trufa troceada. Seguidamente, agregar los espárragos. Poner a hervir una pequeña olla individual con agua y una cucharada de vinagre blanco. Cascar el huevo en un vaso, verterlo en la olla y hervir durante 4 minutos aproximadamente.

Emplatado: Disponer los espárragos en un plato y colocar el huevo escalfado encima. Colar la crema de trufas sobre el huevo y agregar un poco de caldo de ternera.

Un Peu Beaucoup

Design: Line Couvreur | Chef: Jean Engels

Rue de la Paix 22 | 1050 Brussels
Phone: +32 2 503 22 36
Subway: Louise
Opening hours: Mon–Fri from 9 am to 6:30 pm, Wed–Fri from 7:15 pm to 11 pm
Average price: € 20
Cuisine: Fusion
Special features: There is no menu, the dishes change every day. Colorful and eclectic place

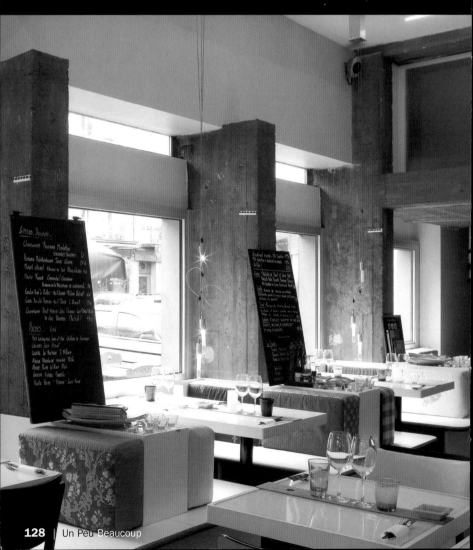

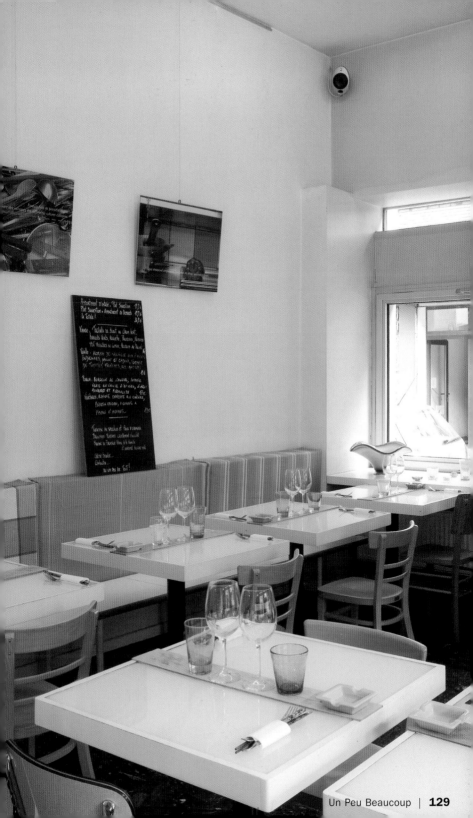

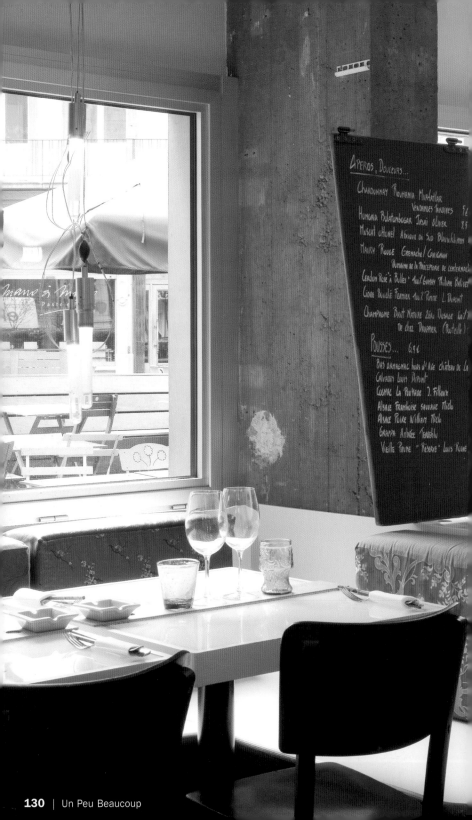

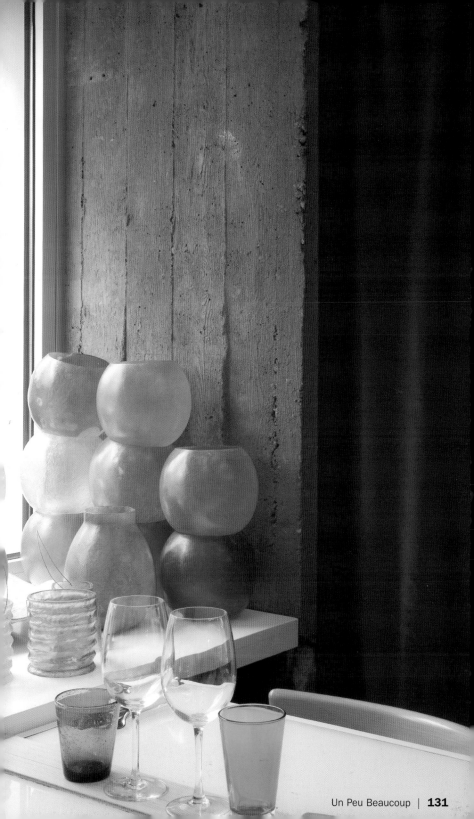

« Tagliata »

de bœuf avec parmesan et humus

'Tagliata' van rundvlees parmezaanse kaas en hummus

"Tagliata" of Beef with Parmesan and Hummus

„Tagliata" vom Rind mit Parmesan und Humus

"Tagliata" de buey con parmesano y humus

1 portion de bœuf de 300 g
4 feuilles de sisymbre
5 ml de vinaigre balsamique
30 ml d'huile d'olive
Sel fin
Poivre noir
30 g de copeaux de parmesan
1 gousse d'ail
2 pommes de terre cuites
10 g de pignons
50 g de humus

Frotter la viande avec la gousse d'ail émincée, l'enduire avec d'huile d'olive et assaisonner. Dans un bol, dissoudre une pincée de sel dans le vinaigre balsamique et émulsionner avec d'huile d'olive. Ajouter 2 feuilles de sisymbre au bol et mélanger. Faire griller la viande sur le gril à feu vif pendant 2 minutes de chaque côté. Ensuite, couper en lamelles.
Presentation : Disposer l'humus au fond de l'assiette. Monter dessus de le bœuf des feuilles de sisymbre, les copeaux de parmesan et les pignons. Arranger avec l'assaisonnement préparé et les pommes.

Stuk rundvlees van 300 g
4 er waten rucola
5 ml balsamicoazijn
30 ml olijfolie
Fijn zout
Zwarte peper
30 g geschaafde parmezaanse kaas
1 teentje knoflook
2 gekookte aardappelen
10 g pijnboompitten
50 g humus

Wrijf het vlees in met het uitgeperste teentje knoflook, olijfolie en zout en peper. Los in een kommetje een snufje zout op in balsamicoazijn en roer er een paar druppels olijfolie door. Voeg 2 er waten rucola toe en roer door. Bak het vlees in een grillpan op hoog vuur voor 2 minuten aan elke kant. Snijd het daarna in plakken.
Serveren: Schep de hummus met op een bord Schik er wat rucola over, de geschaafde parmezaanse kaas en de pijnboompitten en dien op met aardappelen.

.1 oz piece thick cut beef
4 rocket leaves
5 ml balsamic vinegar
30 ml olive oil
Fine salt
Black pepper
. oz slivers of Parmesan cheese
. clove of garlic
2 boiled potatoes
./3 oz pine nuts
. 3/4 oz humus

Rub the meat with the minced garlic clove, cover it with olive oil and add salt and pepper. In a bowl, dissolve a pinch of salt in the balsamic vinegar and emulsify with a olive oil. Add 2 leaves of rocket to the bowl and mix. Cook the beef on a grill over hot flames just 2 minutes each side. Then cut it into slices.
To serve: Put the hummus on the bottom of a plate. Over the beef place rocket leaves, the Parmesan slivers, and the pine nuts. Add the preparated dressing and serve with patatoes.

1 Stück Rindfleisch 300 g
4 Raukeblätter
5 ml Balsamicoessig
30 ml Olivenöl
Feines Salz
Schwarzer Pfeffer
30 g Parmesanspäne
1 Knoblauchzehe
2 gekochte Kartoffeln
10 g Pinienkerne
50 g Humus

Das Fleisch mit der gehackten Knoblauchzehe einreiben, mit Olivenöl beträufeln, pfeffern und salzen. Den Balsamicoessig in eine Schale geben, eine Prise Salz hinzufügen und mit Olivenöl verrühren. 2 Raukeblätter hineinlegen und vermischen. Das Fleisch bei hoher Temperatur 2 Minuten lang von jeder Seite grillen. Danach in Scheiben schneiden.
Serviervorschlag: Den Humus zuerst auf den Teller geben. Das Fleisch darauf legen, die Parmesanspäne und die Pinienkerne anrichten und mit Raukeblättern dekorieren. Mit der Vinagrette übergießen und mit den Kartoffeln servieren.

1 ración de buey de 300 g
4 hojas de rúcula
5 ml de vinagre balsámico
30 ml de aceite de oliva
Sal fina
Pimienta negra
30 g de parmesano en virutas
1 diente de ajo
2 patatas hervidas
10 g de piñones
50 g de humus

Frotar la carne con el diente de ajo picado, cubrirla con aceite de oliva y salpimentar. En un bol, disolver una pizca de sal en el vinagre balsámico y emulsionar con aceite de oliva. Añadir 2 hojas de rúcula y remover. Asar la carne a la parrilla a fuego vivo durante 2 minutos por cada lado. Seguidamente, cortarlo en láminas.
Emplatado: Disponer en abanico los filetes de carne, rodear con humus y coronar con las virutas de parmesano y los piñones. Condimentar con el aliño preparado y decorar con rúcula y patatas.

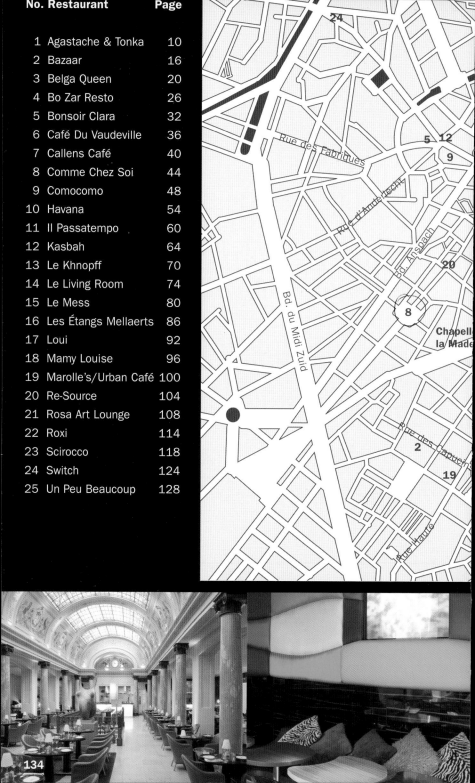

134

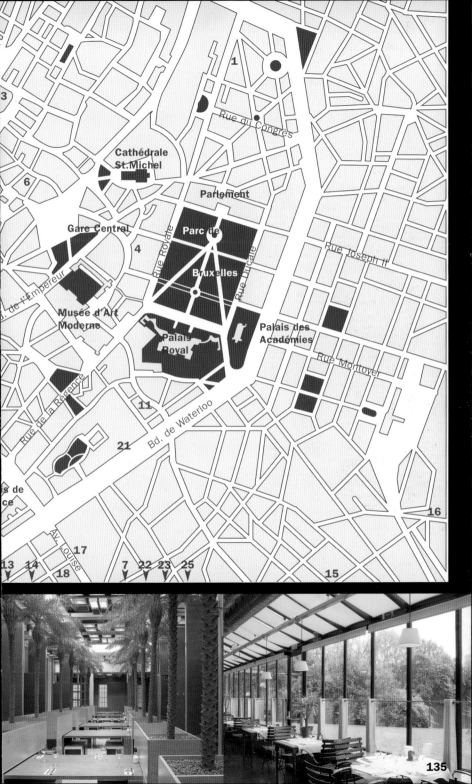

Rue du Congrès

1

3

Cathédrale
St.Michel

6

Parlement

Gare Central

Parc de

4

Rue Royale

Bruxelles

Rue Ducale

Rue Joseph II

B. de l'Empereur

Musée d'Art
Moderne

Palais
Royal

Palais des
Académies

Rue Montoyer

Rue de la Régence

11

Bd. de Waterloo

21

16

s de
ce

17

13 14

18

Av. Louise

7 22 23 25

15

135

Cool Restaurants

Size: 14 x 21.5 cm / 5 1/2 x 8 1/2 i
136 pp
Flexicover
c. 130 color photographs
Text in English, German, French,
Spanish and (*) Italian / (**) Dutc

Other titles in the same series:

Amsterdam (*)
ISBN 3-8238-4588-8

Barcelona (*)
ISBN 3-8238-4586-1

Berlin (*)
ISBN 3-8238-4585-3

Chicago (*)
ISBN 3-8327-9018-7

Côte d'Azur (*)
ISBN 3-8327-9040-3

Hamburg (*)
ISBN 3-8238-4599-3

London
ISBN 3-8238-4568-3

Los Angeles (*)
ISBN 3-8238-4589-6

Madrid (*)
ISBN 3-8327-9029-2

Miami (*)
ISBN 3-8327-9066-7

Milan (*)
ISBN 3-8238-4587-X

Munich (*)
ISBN 3-8327-9019-5

New York
ISBN 3-8238-4571-3

Paris
ISBN 3-8238-4570-5

Prague (*)
ISBN 3-8327-9068-3

Rome (*)
ISBN 3-8327-9028-4

San Francisco (*)
ISBN 3-8327-9067-5

Shanghai (*)
ISBN 3-8327-9050-0

Sydney (*)
ISBN 3-8327-9027-6

Tokyo (*)
ISBN 3-8238-4590-X

Vienna (*)
ISBN 3-8327-9020-9

Zurich (*)
ISBN 3-8327-9069-1

To be published in the same series:

Cape Town
Copenhagen
Dubai
Geneva
Hong Kong
Ibiza/Majorca
Istanbul

Las Vegas
Mexico City
Moscow
Singapore
Stockholm
Tuscany

teNeues